LONDON UNDERGROUND
SERIAL KILLER

LONDON UNDERGROUND
SERIAL KILLER

THE LIFE OF KIERAN KELLY

GEOFF PLATT

PEN & SWORD
TRUE CRIME

First published in Great Britain in 2016 by
Pen & Sword True Crime
an imprint of
Pen & Sword Books Ltd
47 Church Street
Barnsley
South Yorkshire
S70 2AS

ISBN 978 1 47387 2 257

Printed and bound in the UK by
CPI Group (UK) Ltd, Croydon, CR0 4YY

Pen & Sword Books Ltd incorporates the imprints of Pen & Sword
Archaeology, Atlas, Aviation, Battleground, Discovery, Family
History, History, Maritime, Military, Naval, Politics, Railways, Select,
Transport, True Crime, and Fiction, Frontline Books, Leo Cooper,
Praetorian Press, Seaforth Publishing and Wharncliffe.

For a complete list of Pen & Sword titles please contact
PEN & SWORD BOOKS LIMITED
47 Church Street, Barnsley, South Yorkshire, S70 2AS, England
E-mail: enquiries@pen-and-sword.co.uk
Website: www.pen-and-sword.co.uk

Contents

Introduction

Kieran Patrick Kelly spent more than half his life in prison and when he was free, he lived mainly in the commons, parks and open spaces of south London. He had no qualifications and worked as a casual labourer. Twice, he started families with women he married but both relationships ended disastrously within a couple of years and he lost touch with his children.

Kelly was born in southern Ireland, in Rathdowney, County Laois and at the age of around 10, his family moved 74 miles north east, to the centre of Dublin. He remained there, largely until the age of 30, when his first marriage collapsed and he decided to move to London. Despite living in the centre of two congested capital cities, Kelly was strangely invisible and went unnoticed throughout his life. It was this anonymity that allowed Kelly, known to his few friends as, 'Nosey' because of his exceptionally long, curved nose, go about his business. Unfortunately, between 1960 and 1983 Kelly's business was to stroll up and down the platforms of Northern Line stations on the London Underground, approach passengers from behind and, with both hands in his trouser pockets, gently rotate his shoulder to propel the unsuspecting soul underneath a passing train.

In total, Kelly admitted to or was accused or suspected of, 31 murders. This makes him the first Irish serial killer and the second most prolific British serial killer after Dr Harold Shipman. Between 1953 and 1983, he was arrested eight times for eight separate murders by eight different police murder squads. Then he killed a man in the cells at Clapham Police Station having being arrested for being drunk and disorderly. After being questioned by senior

detectives, he admitted to 16 more murders, all of which were re-investigated as a result.

I joined the Metropolitan Police on 10 February 1975 and worked there for 25 years. I started as a uniformed constable and progressed to becoming a crime squad officer and trainee detective working with the CID. By the time I retired, my role was acting detective chief inspector. I first met Kelly in 1983 around 10 minutes before he murdered his final victim in the police cells and I spoke to him about 10 minutes after the crime. The next day, I went to the offices of the *South London Press* newspaper to investigate 'suicides' on the Northern Line. I spent the next week studying the twice-weekly newspapers for the period between 1953 and 1983. When I reported back, I was dispatched to Wandsworth Prison to examine Kelly's prison file. I was then told I would be responsible for arranging his weekly remands and for collecting, collating and updating all the case papers for court. I met Kelly almost every day for the next two years, throughout the investigation, his weekly remands in custody, his committal to the Central Criminal Court at the Old Bailey and the subsequent six months of mistrials and retrials in Court Two.

On 21 April 2015, shortly after the National Archives at Kew released the Kelly case papers under the Freedom of Information Act, I published the book *The London Underground Serial Killer* about the 1983 investigation and my subsequent dealings with Kelly during the trials at the Old Bailey. Following publication, seven more people came forward alleging murder against him. Amid the media circus that erupted as a result of my book, the press claimed that I accused the Metropolitan Police of a cover up but that is not quite correct. During an interview I was asked why Kelly's story had not been publicized at the time and I attempted to explain that the Home Office had feared it would stop people using the Northern Line and might cause widespread panic. As a result, they had instructed the Metropolitan Police not to discuss the case with the press or answer questions on it.

However, the media interest from my book prompted the Commissioner of the Metropolitan Police, Sir Bernard Hogan-Howe, and the Chief Constable of the British Transport Police (BTP) Paul Crowther to discuss the case and see what action was now required. This was complicated by the fact that although the BTP had been formed in 1948, it had not been authorized to investigate murders until 2000. Between 1948 and 2000, any murders had been investigated by the police force local to where the crime had taken place or where the body was found. Thus, between 1953 and 1983 all the initial enquiries had been conducted by the Metropolitan Police, as had the investigation in 1983.

Hogan-Howe and Crowther agreed that the BTP's Detective Superintendent Gary Richardson (who had been awarded the Queen's Police Medal for services to policing) would lead his major incident team of 24 elite detectives to re-investigate all Kelly's suspected murders between 1953 and 1983. He invited me to act as a consultant to the enquiry and so the story of the London Underground serial killer was reborn.

The Early Years in and Around Dublin – 1930 to 1960

*All the facts in this chapter were supplied to me
by Kelly following his arrest in Clapham in 1983.
I verified them at the time and later spoke to the
various registrars of births, marriages and deaths,
the parish priest of St Kevin's Church in Dublin
and the principals of the two Synge Street schools
to ensure that the information is accurate.*

Kieran Patrick Kelly was born on 16 March 1930 to Martin Kelly and Annie Kelly (née North). His parents had married on 5 November 1924 at the Roman Catholic Church of Our Lady of Dolours, 287 South Circular Rd, Dolphin's Barn, Dublin 8, Ireland. Kieran had an older brother Martin (date of birth unknown) and was followed by a sister, Mary Elizabeth Kelly (born on 6 August 1932) and a younger brother Michael John Kelly (born on 15 June 1934). The children were all born in Ballybuggy near Rathdowney (Irish: *Ráth Domhnaigh*), a small town south of Dublin, in south-west County Laois, in the province of Leinster. It lies around 20 miles south west of Portlaoise in the Irish Midlands, at the intersection of two roads, the R433 from Abbeyleix to Templemore and the R435 from Borris-in-Ossory to Johnstown.

At the time of his marriage in 1924, Kieran's father, Martin Senior, reported that he was employed as a police officer. Six years later, at the registration of Kieran's birth, he attested that he was employed as an insurance agent and when registering his youngest son Michael's birth in

1934, he said he was working as a labourer. The family's circumstances were clearly not improving.

In our discussions following his arrest in 1983, Kelly, then 53, told me he was proud that his family had baptized him in the Roman Catholic faith days after he was born and he was equally proud that he'd been enrolled in the Irish Republican Army (IRA) a few days later. Both these organizations had arranged for him to be educated in the requirements of membership and the one thing they had in common was a hatred of homosexuality. Due to his youth, Kelly was unsure exactly what homosexuality was and had to wait many years to find out and understand why it was so unpopular.

Religion has always been important in Ireland. The population is divided between Roman Catholics and Protestants and for the last century this has caused considerable political and cultural conflict and not a little violence. Kelly's family were Roman Catholics and in such a small community with so few facilities, the church would have been a major influence on life and provided most of the entertainment. Saint Andrew's Church, which dominates the square, and to a lesser degree the town of Rathdowney, stands on the site of a Roman Catholic church, which was located there from medieval times until the Reformation. A Catholic church was constructed on Main Street in the 1830s and this served the area for the next 120 years before it was replaced by a shrine and a car park. The larger, modern Church of the Holy Trinity was built on the west side of the town in the late 1950s.

In a community that has only recently exceeded a population of 1,000, there is only really space for one large employer. Between 1800 and 1968 that was Perry's Brewery but in 1968 the site was sold and became the Meadow Meats processing plant. Since then, Dunnes Department Store, which was founded in 1944, has been the largest employer and has made Rathdowney something of a centre for several outlying villages. It is not known if any members

of the Kelly family worked for these companies, although Martin Senior definitely did not.

By the time the Kelly family left Rathdowney for Dublin in 1940 tensions in Ireland had started to calm down. The Irish Civil War had ended, self-rule had been established, the famines appeared to be over and the criminal gangs that had been troubling the north of the city were being subdued. Although the Second World War – known in the Republic as 'The Emergency' – was in full swing, the Irish Government had declared its neutrality and was resisting British attempts to conscript its citizens. Despite this, Ireland was victim to a number of bombing raids with a total of nine bombs landing on its capital city.

Kelly was 10-years-old when he arrived in Dublin. The reason for the move is unclear and in our discussions he was unable to shed any light on it. However, it was probably related to the education and employment opportunities that the city had to offer. Not that the streets were paved with gold. There was a great deal of poverty in Dublin, especially in the inner-city's festering, squalid tenements. Violent gangs, nicknamed the 'animal gangs' prowled the city, using iron hooks, knuckle dusters and potatoes spiked with razor blades in their brawls.

Martin and Annie Kelly took up residence with their four young children, Martin Junior, Kieran, Elizabeth and Michael, in a small tenement at 43 Harcourt Street. It was on the south side of Dublin, in a deprived inner-city area between two large city parks, St Stephen's Green and Iveagh Gardens, and close to the seat of the Irish Government.

As committed Roman Catholics, the Kelly family regularly attended St Kevin's Church in Harrington Street, Dublin, a third of a mile south of their family home. Known locally as the Harrington Street Church, the parish covered an area bounded to the north by Long Lane, Camden Row and Montague Street, to the south by the Grand Canal, to the west by Dufferin Avenue and to the east by Harcourt Street. The Kellys actually belonged to another parish but when they had first arrived, they had lived for a short while

in another flat. Although it was in the same block as their new home in Harcourt Street, it had an entrance in another road, which was in St Kevin's catchment area. Presumably the family liked St Kevin's, liked the parish priest, had friends in the parish and decided against moving to the new parish, despite it being a requirement to do so. All the Kelly children were confirmed at the Harrington Street Church and Kieran was 12 when, on 19 February 1942, he received the sacrament of confirmation.

Kelly's life was affected fundamentally by this decision not to change parish. Not only did he continue to attend St Kevin's, he also went to Synge Street Christian Brothers School, which was next door to the church. This apparently insignificant, administrative convenience had a fundamental effect on his education, morality and philosophy and it would affect the person that Kelly became in later life: a serial killer.

Founded in 1864 and known locally as 'Synger', the school is named after the religious order that established and runs the school. The Christian Brothers, a community of religious brothers within the Roman Catholic Church founded by Edmund Ignatius Rice in 1802, were dedicated to educating Catholic boys, mainly from disadvantaged communities. They had a fearsome reputation for imposing fiendish discipline on their young charges. The school recently attracted considerable attention after being the setting for the 2016 musical film *Sing Street*, which tells the story of a boy growing up in Dublin in the 1980s, who escapes his strained family life by starting a band to impress a girl.

Kieran and his brother Michael enrolled at Synge Street as soon as they arrived in Dublin. Kieran would stay there four years until he was 14. He spoke proudly of the time that he and his brothers spent at the school and the boys that he met there. School life was hectic. He always arrived early and had breakfast there and went to after-school clubs that occupied his time into the evening. Unfortunately, the school was re-organized in 1954 when the primary school

was renamed the Sancta Maria Christian Brothers Boys' School and the secondary school was renamed the St Paul's Secondary School, Heytesbury Street. Although records show that Michael was a pupil there, none of Kieran's school records can be found.

Synge Street has an incredible record of academic, sporting entertainment and celebrity success. Former pupils include Cearbhall Ó Dálaigh, who was the 5th President of Ireland between 1974 and 1976 and Liam Cosgrave, who was Ireland's Taoiseach (prime minister) from 1973 to 1977. Another pupil, Liam Whelan was a Manchester United footballer and one of the eight 'Busby Babes' to die in the Munich Air Crash in 1958. Formula One boss Eddie Jordan and *This Is Your Life* presenter Eamonn Andrews are also old boys.

Any spare time after school, at weekends or in school holidays was usually spent at St Kevin's Church, which is where Kelly attended weekly Sunday school. There he was taught the Roman Catholic catechism and Christian beliefs. The one that left the greatest impression on him was that homosexuality would lead to hellfire and damnation. In the 1940s, young people weren't taught sex education until a few weeks before they left school, and even then they were given the basic facts. Young Kelly wasn't exactly sure what homosexuality was but he knew the word and knew it was unnatural and a terrible sin. His parents had told him this repeatedly, as had the Christian Brothers who taught him at Synge Street.

Much of the public agreed with the views of the church. Until 1967 it was a criminal offence to be a homosexual man and many men felt justified to beat up gay men on sight. A policeman informed of such an assault would have been very unlikely to feel any sympathy for the victim or want to arrest or prosecute the offender. Most homosexuals stayed 'in the closet' simply to preserve their safety or even their life. Tolerance was widely seen as a weakness rather that a human right.

As he reached his midteens, it troubled Kelly to discover

that he was experiencing homosexual tendencies. This worried him gravely as from an early age, he had been told it was a terrible sin and he knew that his world as he knew it would end if his family and friends found out he was that way inclined. He struggled to suppress his feelings and to conceal any evidence or gossip suggesting that he might be attracted to men.

Following his arrest in 1983, Kelly explained clearly the lengths he'd gone to throughout his early life, to conceal his true identity. He avoided homosexual relationships, knowing that in such a close community he would have no chance of avoiding detection. Despite a lack of interest in girls and women, he actively sought out female company in order to deceive those who suspected his true interests. He would keep heterosexual pornography in his bedroom, making it look as though it had been carefully hidden, but leaving it in places he was confident his mother would find. He strictly avoided buying gay pornography as he knew news of that would reach his family and friends. He listened carefully to claims of sexual conquests made by his friends, so that he could make similar claims himself. As he got older, Kelly engaged in sexual activity with women and left evidence to be found by family and friends so they were reassured he was behaving like any other girl-crazy young man.

It was important to Kelly to have the love and support of his family and he knew that outing himself as a homosexual would destroy their relationship with him. Although the deceit was difficult for him to maintain, he was disciplined enough to continue the ruse as the alternative was not worth thinking about. As he left his teenage years and moved into his twenties, Kelly was confident that his secret was safe and that neither his friends nor family had any suspicions about his sexuality.

When his best friend, Christy Smith, proposed that he and Kelly travel to London with two girls to see the coronation of Queen Elizabeth II in 1953, Kelly happily agreed. When, in London, Smith made an entirely innocent comment to

Kelly: 'Hey Kelly, you're 30 now. It's about time you got married.' Kelly, who was actually only 23-years-old at the time, felt his world collapse around him. He immediately assumed that instead of simply joking around, Smith was letting him know that his secret was out and that he knew Kelly was a practising homosexual. A few hours later Kelly pushed Smith underneath a London Underground train. A few weeks later, having made his way back to Dublin, he expressed surprise when he was asked about Smith. 'Oh, hasn't he come back already?' asked Kelly. 'Maybe he stayed on with that girl he liked.' Eventually, the questions stopped and Kelly got on with his life, confident once more that his secret was safe.

Around 1957 or 1958 Kelly got married in Dublin and had two children. This marriage, just like the life he led with his parents and siblings, was a lie. However, he was so keen to be accepted as conventional that he was disciplined enough to keep his secret. Unfortunately, in 1960 his wife deserted him and took their two children with her. Kelly says he had no idea why the marriage failed, although he did think his poor sexual performance, due to the fact he wasn't interested in woman romantically, may have played a part. He strongly denied that his wife was aware of his sexuality but with the marriage now over, he took the opportunity to run away to London, never to return to Dublin.

Another question denied by Kelly was whether he was sexually or physically abused as a child growing up in Ireland. This was raised repeatedly during the course of the original investigation in 1983 and during his trial at the Old Bailey. It has also arisen again in recent presentations of the case. There is ample research evidence to support the view that the vast majority of the men engaged in sexual violence – as Kelly was, often attacking homosexual men by shoving glass bottles up their anus – have been abused themselves as children. Plus, in our prolonged discussions following his arrest, when Kelly and I discussed his motives for killing so many people, he always started by going back

to his teenage years at St Kevin's Church and Synge Street school. This begs the question: did something dreadful occur during this pivotal time that affected his behaviour later on?

However, Kelly always vehemently denied that he had been abused and swiftly changed the subject. When I returned to the question and pressed him further, he became violent. Although this isn't uncommon when a victim feels guilt or embarrassment, however unjustified, there is no evidence to support any abuse in Kelly's early life. His childhood home in Harcourt Road was small and as he had a large family, space was severely limited so no relatives or friends were invited to stay with the family. Since his brothers were very close in age to him, it is unlikely that any of them abused him and there is nothing to suggest his father did. It is possible that he was assaulted in school or church but Kelly was adamant it did not happen. Perhaps it wasn't abuse but a deep-seated fear that he would be outed as a homosexual that prompted the violence that escalated throughout his life.

Kelly left school in 1944, aged 14, signed a six-year indenture and became an apprentice tailor's presser in Dublin. It is likely that initially he would have been responsible for collecting and delivering the clothes to be pressed, making cups of tea and coffee and shadowing a skilled presser at work. Health and safety legislation at the time would have prevented him from using a Hoffman Press – the large ironing machine controllable by foot – until he was at least 15-and-a-half-years-old. Completing an apprenticeship meant that Kelly would have a job for life. If he were to fall on hard times and options were to become limited, he would have a job to fall back on. No doubt he would have become bored by the repetitive nature of the work after several years, but the promise of security meant that he really had no alternative but to see out his six years and complete his apprenticeship.

He was 20-years-old when he completed his apprenticeship. However, jobs in 1950 Ireland were hard

to come by, even in the capital city, and unemployment among school leavers and young people was high. Many of Kelly's contemporaries would have moved to England seeking work as labourers, but Kelly was hindered by his size. At 5ft 8ins (1.73m) and 143lb (65kg) he would have been overlooked for heavier, stronger men by the four major companies – Sir Robert McAlpine Ltd, George Wimpey Ltd, MJ Gleeson Ltd and John Laing Group plc – who were engaged in building roads, railways, housing and industry in London. At this time, they relied on recruiting vast numbers of former Irish farm boys, with hands like shovels, to dig roads, railways and tunnels for the London Underground. There was no machinery, so everything was done by hand. While policemen at this time were paid £6 per week, Irish navvies were paid £3 and given eight pints of Guinness a day to slake their thirst and build them up. Nobody seemed to care where or if they slept. Many were hired on a day-by-day basis, being lined up at 5.30 am every morning and being paid cash in hand at the end of the day. Competition was fierce and clearly, nobody was going to select a man as slight as Kelly, so he had to look elsewhere.

On 21 February 1950, a month before his 20th birthday, Kelly went to Belfast to enlist in the British Army as a guardsman in the Irish Guards. He was allocated the Army number 22216332 and was described as being in good health with a fresh complexion, blue eyes, fair hair and a vertical scar across his right fingers. His NHS Number was TZ089372C.

There was a considerable amount of anti-British sentiment in Dublin at this time and exactly what motivated Kelly to join the British Army is unclear. There is evidence to suggest that several generations of his family had served over the years, which may explain his decision. Clearly, Rathdowney, where Kelly was born, had a proud history of service to the British Army. Many of its residents had served with distinction and two had been awarded the Victoria Cross for valour. Additionally, the British Army had smarter uniforms with which to impress

the women, bigger and better weapons to fight the enemy and a far higher salary than the Irish Army. His diminutive stature would not have been an obstacle to his enlisting. Between 1945 and 1952 the British Army was a conscript army, totally reliant on National Service men. Volunteers were hard to come by and treated much better than the conscripts.

Kelly served at Pirbright Camp in Woking in Surrey, which was a centre of excellence for sniper training and where those who were considered to have potential as snipers were sent. Clearly, Kelly must have scored very highly in target shooting during his initial training. Trainees were taught to use a range of weapons, from sten guns to Brownings, but the final assessment relied on their performance using a Lee-Enfield .303 rifle, which had considerable recoil and which would have caused a slight man such as Kelly serious problems. This may explain his decision to desert. It was likely he realized he was not going to pass his sniper training and secure the job that he wanted and instead of seeing the training through, with the same commitment and dedication he showed during his long tailoring apprenticeship, he ran away. He had been training for 22 months when he deserted Pirbright on 10 December 1951. However, he was quickly captured and discharged from the Army.

From Pirbright, Kelly returned to Ireland but avoided Dublin and instead found work as a farm labourer in southern Ireland, in County Laois, the county of his birth. It was here that he started to display antisocial behaviour and he was arrested for theft on 7 February 1953. Having lost his job, he then returned to Dublin and met up with his old friend Christy Smith, who suggested the fateful trip to London for the Queen's coronation. Upon his return from London, minus Smith, whom he had murdered after pushing him under a tube train for making an innocuous comment about his bachelor lifestyle, Kelly settled in Dublin, working in a variety of jobs as a casual labourer. During that time he continued to break the law and between

1953 and 1960 amassed six convictions in Dublin courts. Kelly was settling in to a life of crime that would end the life of so many innocent souls.

The Middle Years in London – 1960 to 1983

It was no surprise that Kelly left Dublin for London following the break up of his first marriage in 1960 when he was 30-years-old. Despite only visiting the capital once before, when in 1953 his best friend, Christy Smith, proposed that they take two girls to London to watch the Queen's coronation, he had got to know various parts of the city and its anonymity suited him.

During his visit in 1953, when he arrived with Smith but left alone, having thrown his friend to his death under a tube train, Kelly had stayed in digs in Tooting Bec in the south of the city. He also frequented the open spaces of Clapham Common, Tooting Bec, Camberwell Green and Kennington Park and travelled up and down the Northern Line of the London Underground, mainly to keep warm and dry. Therefore, when his wife left him and took their two children with her, Kelly fell apart, ran off and did not stop running until he found himself in the only place on the planet with which he was familiar, but that was not in, or very near, Dublin. In doing this, he abandoned his parents, siblings, friends and job and he never saw any of them again.

He gravitated once more to south London and stayed on the couches and floors belonging to friends; young Irish men who along with many others had made the trip from Dublin to London to find work. With little employment in Dublin and with England using money from the Marshall Plan (the US initiative to rebuild West Europe after the Second World War) to stimulate major infrastructure projects in road, rail, underground and housing, there was a

constant need for Irish muscle. Kelly was among thousands
of Irish men who made London their home in 1950 and
he relied on the kindness of those who had already settled
in to the capital. He moved around, never outstaying
his welcome and at one stage or another called Brixton,
Borough, Camberwell, Clapham, Peckham, Anerley and
Walworth home. These young Irish men were a close-knit
group, sharing accommodation, entertainment, social and
support structures. They helped each other out and liked
to play as hard as they worked.

Kelly's slim build meant he wasn't really suitable for
building work and instead he decided to utilize the skills
he'd acquired during his six-year tailoring apprenticeship
and look for work as a Hoffman presser. But work was hard
to come by and he soon realized that in order to survive,
he would have to be less discerning and take any jobs that
he could find.

It wasn't long before he met Frances Esther Haggans,
née Territt, who was also Irish. Born in May 1932, she
came from Athey in Kelley's birth county of County Laois,
37 miles from his birthplace, Rathdowney. Like Kelly she
had been married before, yet she had recently learned that
her husband, William Daniel Haggans, who was eight years
her senior, had already been married when they met. Thus,
their marriage at Hendon Registry Office in Middlesex,
north London on 2 February 1952, had been bigamous.
Esther, as she was known, had seen her husband sentenced
to prison for the offence of bigamy and she had been issued
with a certificate from the High Court in London certifying
that she was, in law, a single woman and entitled to marry
again as a spinster.

After a brief courtship, Esther and Kelly were married
on 25 March 1961 at the Sacred Heart of Jesus Roman
Catholic Church in Camberwell. Kelly gave his occupation
as tailor's presser and Esther gave hers as restaurant cook.
Esther came with five children from her bigamous marriage
and Kelly readily accepted the four girls and one boy as
his own. They were Celia Annette, who was seven, Annette

Margaret, who was six, four-year-old Denise Margaret, William Daniel who was almost two and eight-month-old Elizabeth.

The new Mr and Mrs Kelly and their five charges started married life at 4, St Paul's Terrace Walworth before moving to 109, Poynders Gardens, Clapham. It wasn't long before they had two children of their own: Karen Patricia who was born on 5 December 1961, less than nine months after the wedding and Dennis Martin who came along just over two years later on 7 January 1964.

It was a considerable undertaking for a man to assume responsibility for a ready-made family with five children under eight. Kelly was in short-term, casual employment at this time and with few academic qualifications and few skills aside from tailoring, an industry in which he had struggled to find work, his potential was limited. Having lost touch with his family when he left Dublin, there was no way he could lean on them to help him out financially. It was clear he was planning to rely on social security benefits, and possibly petty crime, in order to support his new family.

However, it is not known if Kelly and Esther married because they knew baby Karen was on the way. Esther would have been a few weeks pregnant when she walked down the aisle and having endured one bigamist marriage, she may not have had the stomach to bring another child into the world in an insecure relationship. It is also possible, however, that Esther knew that her first husband, William Haggans, was already married when they had their own wedding, and that she was a co-conspirator in the bigamy. A cynical old detective might even suspect that when Haggans was arrested and charged with bigamy, he and Esther discussed the ways in which she might support their children while he was in prison. They may have agreed that she would take advantage of the certificate with which she had been supplied by the High Court, and take another husband until Haggans was eventually released from prison and they could resume their relationship.

Nevertheless, it was perfectly legal of her to marry Kelly. The more interesting question for the priest conducting the new marriage was whether Kelly was entitled to marry Esther. She had her piece of paper from the High Court certifying that her marriage to Haggans had been declared null and void and that she was entitled to marry as a spinster. But what of Kelly? His wife had very recently abandoned him in Dublin. His life had fallen apart and he had run off to live in London and make a new start. Would he really have stopped to instruct a solicitor to arrange a divorce? Did Kelly and his wife even know of each other's whereabouts? In the few weeks between his wife leaving him and him marrying Esther, he had frequently changed addresses in Tooting Bec, and had slept outside in Clapham Common and Camberwell Green. Could a solicitor have kept in touch with the constant flow of correspondence necessary to complete a divorce? Could Kelly and his first wife had been able to afford a divorce? She was, after all, now a single mother with two children and he wasn't in a steady job. Although there was legal aid and social security, it was still not a viable option in most cases. Perhaps Esther twice married bigamists. Maybe she did so unwittingly or perhaps she did know but didn't care as she simply wanted a man, married or not, who would look after her and her growing family.

That theory seems the likeliest because shortly after Dennis's birth, Haggans was released from jail, having served a three-year sentence for the bigamy. Suddenly, Esther upped and left, deserting Kelly and taking all seven children to live with Haggans. Kelly had now been abandoned by two wives in four years and at the same time lost contact with all four of his children. His life, unsurprisingly, fell apart yet again.

Kelly took to living in the parks and commons of south London, including Clapham Common, Tooting Bec, Camberwell Green and Kennington Park. These were large open spaces with substantial vagrant communities providing life's essentials. There was a great deal of alcohol

and a good amount of drugs, both prescription and recreational, as well as food. With no television or books there was little to entertain the residents, but conversation, sleep, stupor and sex in the bushes.

Since his teenage years, Kelly had enjoyed 'a good drink' and had been acutely aware of his homosexual tendencies. He had struggled with both urges for years but with the support of his family and the convention of marriage and fatherhood, he had been able to control both to an extent and live the life of an average family man. With these gone and with no one to rein him in, those urges were unleashed on the world.

With no responsibilities, Kelly was able to drink as much as he wanted, have sex with anybody he wanted and forget his two wives, four children and all his problems. Life quickly became an orgy of sex, drugs and alcohol. Yet he was battling his own demons as he was trying to come to terms with his homosexuality, his failure to make his two marriages work and his four lost children. He also suffered terrible guilt for killing his best friend and was unable to understand what had made him do it. He did it, most probably, because he believed Smith was threatening to disclose his terrible secret and the killing had silenced him. Yet Kelly struggled to understand how he could have reacted so murderously. This was his best friend after all.

Nevertheless, the number one problem in Kelly's life was understanding how he could possibly be gay. He identified as a fully paid-up member of the Roman Catholic Church and the IRA and both organizations despised homosexuality and reviled those who participated in it. He had been brought up with these views engrained in him. So why did he feel 'that way' about other men? It made no sense. Kelly supported the views which he had been taught all his life. It had never occurred to him to challenge these views or reconsider them in any way. He hated homosexuals as much as anyone.

He also struggled to understand why his two wives had left him. Of course, he wasn't a perfect husband. There had

been arguments and even some violence on occasion. Yes, there had been times when he'd had a drink and with his lack of permanent work and two ever-growing families, there had been financial problems. Yet this was typical of most marriages at the time and most of them survived. He wondered if the fact he was attracted to men meant he had failed to satisfy his wives sexually. Perhaps his wives had found out that he was living a lie and instead of confronting it, simply upped and left. The not knowing tortured him.

Without any family, he relied on his friends and associates and he enjoyed his popularity among the vagrant community. Over the years, he had learned to supplement his meagre income by stealing. He was a skilled shoplifter and seemed content to provide for the entire group as it gave him power and made him feel needed and special. Every day, he would plunder the local convenience shops for beer, cider and sherry and share it with his homeless friends. Most of the time, everyone was so drunk or high, they didn't put up much of a fight if he decided that in return, he would like to have sex with them.

Homelessness meant that while it was incredibly difficult to find work, he was still entitled to receive social security benefits. However, the Department of Social Security (DSS) required all recipients to supply their home addresses, and thereafter sent all communications by post to that address. Kelly and his friends, of course, were unable to comply with this requirement and thus they were supported by the DSS Office in Marshalsea Road in Borough, between London Bridge and Elephant and Castle. They were also required to supply their fingerprints as an extra form of identification.

The regular weekly payments to Kelly and his fellow down and outs were made by fixed appointment at Marshalsea Road although people would turn up at all times of the day and night with tales of woe and pleas for cash. Like Kelly, many of these men (as they were predominantly men) found it difficult to support themselves on the sums provided and felt compelled to resort to crime. This meant that police

officers would frequently be waiting at Marshalsea Road to arrest the men when they arrived to collect their benefits and large numbers would be prosecuted on arrival. Despite living a rootless, nomadic lifestyle, the need for money and a warm bed at night meant these people could usually be located pretty quickly. This might account for why Kelly was arrested and convicted so many times. He could run but he couldn't hide.

Kelly did get away from the neighbourhood on a regular basis but he always came back. His favourite outdoor residences, Clapham Common, Tooting Bec and Kennington Park were all close to stations on the southern extension of the Northern Line, so he could easily move between them if supplies ran short or he wanted to find a friend for clandestine sex. At this time, the London Underground was largely unsupervised. There were no access gates controlling access to the platforms, CCTV cameras and very few patrolling staff. Kelly soon learned that he could do as he wished below ground level, on the platforms or in the trains.

Sleeping out for a night or two is not too difficult, especially during the summer months, when the weather is warm and dry. However, living rough for extended periods, particularly during the winter months, is an entirely different prospect. After a few months, most people appreciate the opportunity for a soak in a hot bath, the chance to shake out a few bugs, to eat a hot meal and sleep in a comfortable bed. Kelly was no different and there were three hostels that he used for respite care when he needed it: The Spike in Peckham, Cedars Lodge in Clapham and Rowton House in Vauxhall.

The Spike, located between Consort Road and Gordon Road in Peckham Rye, was also known as the Camberwell Reception Centre. At its peak, it consisted of eight dormitory blocks, each housing 140 men. Doors would open at 4.00 pm and the queue would stretch for several miles. The name 'The Spike' came from the practice of keeping two spikes in opposite corners of the yard and a

rope slung between them, which meant men without a bed could fall asleep standing up leaning against the rope to avoid sleeping on the wet ground.

Rowton House was on the south side of Vauxhall Bridge and Kelly used it as a respite centre, when the weather deteriorated, or when he needed a bath or a clean up after too long sleeping outside. He could have arranged to live there permanently but felt that it restricted his ability to do as he wanted such as drink alcohol, take drugs and have sex.

Cedars Lodge in Cedars Road, Clapham was originally an old people's home and today it is occupied by the homeless charity, St Mungo's. Kelly stayed there many times and when, following one of his many brushes with the law, the director of public prosecutions required an identification parade for Kelly, this was where it took place. The resulting mob fight is set out in full later on in the book.

Over time, Kelly began to rely more on aggressive behaviour to get what he wanted. He would intimidate shopkeepers to the extent that most would let him off for stealing without reporting him to the police. However, one or two were prepared to challenge his regular shoplifting sprees or call the police and have him arrested. Kelly got to spend regular periods in prison and, as his list of convictions got longer, so did his terms of imprisonment. Everybody is subject to laws, regulations and customs, even if they live on the edge of society and in the open air. Even when Kelly was homeless in the latter half of the 20th century, many parts of The Vagrancy Act of 1824 were still in use and homeless people could be prosecuted for various offences. Begging was punishable by one month's imprisonment, sleeping in a barn or unused building could earn you three months in prison. Life on the commons, parks and open spaces of south London brought Kelly to the constant attention of the police who could arrest him simply for being drunk in a public place. The vagrant community also imposed their own rules, which included doing what you've got to do to survive, not getting involved

in other people's troubles, avoiding police and authority figures, sharing what you've got with your friends, keeping away from the regular community and accepting there's no privacy, not even for the toilet or sex.

On 9 July 1965, just 18 months after the birth of his youngest son Dennis, Kelly went to Lambeth Magistrates Court to obtain a separation order from Esther. Ten days later he was back, facing six charges of theft. On 11 August 1966 at South Western Magistrates Court in Battersea (now Lavender Hill Magistrates Court) the separation order was discharged and on 11 December 1969, Kelly and Esther were divorced. He was not in court to hear his divorce because a few months earlier he had been arrested for armed robbery and, following an appearance at the Old Bailey, he was convicted and sent to Broadmoor Hospital in Crowthorne in Berkshire. Broadmoor was one of three high-security psychiatric hospitals in England and Kelly was sent there on a hospital order, which meant it had been decided that he was not mentally stable and required medical treatment. A few years earlier, Broadmoor had been described as a hospital for the criminally insane, which although less politically correct, may better describe its purpose.

However, the doctors must have been satisfied that Kelly was not insane, because within two years he was at liberty again. Once again he was arrested for armed robbery and, following another appearance at the Old Bailey, he was convicted and sent, once again, to Broadmoor, yet again on a hospital order. This is somewhat surprising, as throughout all my meetings with Kelly, it never occurred to me that he required psychiatric support and to the best of my knowledge, no such opinion was ever expressed by any of the specialists who assessed him during the trial process. It seemed that Kelly was simply bad and not mad.

For the 18 years between 1965 and 1983, Kelly spent two thirds of his life incarcerated, usually in Brixton and Wandsworth, the two prisons in south-west London. Kelly was fortunate that his many misdemeanours didn't lose

him his life. The last executions, by hanging, took place in 1964, one year before Kelly's first substantial stretch. In November 1965 the death penalty was abolished. Many of Kelly's crimes were committed before this new law was implemented and he's lucky that he didn't get arrested at the time of the misconducts and convicted shortly after, as then he would most probably have been sentenced to death.

Prison life must have been hard, but possibly not hard enough as it didn't deter Kelly from repeatedly re-offending and returning to live under lock and key. It's likely he would have met some interesting characters from the world of crime and celebrity and possibly shared a table with them at mealtimes. Rolling Stones singer Mick Jagger was brought to Brixton Prison in tears in 1967 after being found guilty of drug charges and the notorious Kray twins, Ronnie and Reggie, were remanded there from early 1968 to late 1969 when they were convicted.

Every time Kelly was remanded in custody to be sentenced to a term of imprisonment or prior to appearing at the Old Bailey, he would spend time living in Brixton Prison. In 1983, when he was remanded in custody for five murders, he was sent to the prison hospital for assessment. It was from here that he would be collected weekly and conveyed to South Western Magistrates Court to appear for his regular remand appearances. He remained at Brixton for the duration of his numerous trials and retrials at the Old Bailey in 1984.

Wandsworth Prison is the largest prison in the UK and one of the largest in Europe. Originally built to the humane separate system, with each prisoner having an individual toilet, these were subsequently removed to increase prison capacity and not restored until 1996, so that prisoners had to 'slop out' (empty their waste from a bucket or chamber pot) every night. Just as he had missed the death penalty by one year, Kelly was fortunate to miss out on the practice of flogging and whipping from the birch and cat o' nine tails. In 1951, Wandsworth was the holding prison for a national

stock of these implements of corporal punishment, which were inflicted as a disciplinary penalty under the prison rules. An example of a flogging with the 'cat', carried out in Wandsworth Prison was reported in July 1954.

Again, due to the amount of times he attended prison, it is likely Kelly came across some of its most infamous guests and may have been inside on 8 July 1965 when Ronnie Biggs escaped from Wandsworth, having served only 15 months of a 30-year sentence for his part in the Great Train Robbery. In the 1970s, Wandsworth Prison was also home to Michael Peterson, otherwise known as Charles Bronson and Britain's most violent prisoner. No doubt the diminutive Kelly would have steered clear of Bronson who had a fearsome reputation and while in Wandsworth, attempted to poison a fellow prisoner, kill a prison officer and dig his way out of his cell.

Whoever he met and whatever he learned in prison from his many stays inside, it never convinced him to lead a crime-free life. In fact, each time he was detained at Her Majesty's pleasure, he probably picked up more tips and skills that allowed him to continue wreaking havoc on the outside and taking so many innocent lives. Prison life was proving no deterrent to Kelly who was destined to live a life of murder.

CHAPTER 3

Kelly's First Murder

B etween 1953 and 1983, Kelly admitted to a large
number of murders. Some he did commit and some
he possibly did not. When you are suspected of 31
murders, you meet a lot of policemen. Kelly would play
with them. Sometimes he would admit to several murders,
knowing that he had not committed any of them, just to
leave doubt in the mind of the investigator. Sometimes
detectives were able to prove that he had committed a
murder and sometimes they could not. Sometimes Kelly
would admit a murder to one detective and then a few
minutes later deny it to the man's colleague.

However, the one case that he constantly and consistently
admitted and kept returning to is his first murder –
that of his best friend, Christy Smith. He admitted it
wholeheartedly to every single detective. He had to. It
haunted Kelly; it was in his thoughts night and day and he
just could not get away from it. In his mind this is the crime
that made him the person that he was and the one that
led him to kill so many other people. And yet, bizarrely,
there is absolutely no evidence to support his admission.
Strenuous and repeated investigations into this crime have
failed to corroborate any aspect of his confession. There is
no record of any person named Christy Smith having been
born, married, lived or died in or around Dublin. There is
no record of anybody called Christy Smith having served
in the British Army. There is no record of any person falling
under a London Underground train around the time of
the Queen's coronation. Of course, this does not help us
to understand Kelly's obsession with the incident and his
deep-seated belief that it happened exactly as he told it.

On 2 June 1953 Queen Elizabeth II of the United

Kingdom, Canada, Australia, New Zealand, South Africa, Ceylon (now Sri Lanka) and Pakistan was crowned at Westminster Abbey. Approximately 8,000 VIP guests (mainly heads of states) received personal invitations and attended the ceremony. Around three million people lined the route and several million more begged, borrowed and bought television sets in order to watch the world's first major televised event. A less predictable consequence of the event, which had not been foreseen in the preceding 16 months of planning led by Prince Philip, the Duke of Edinburgh, was that a small, scruffy Irishman from just outside Dublin would come to London for a party and while he was there, get a taste for killing people. That taste would develop into a ferocious appetite and stay with him for the next 30 years, during which time up to 31 people, most of them strangers, would lose their lives. Kelly didn't know most of his victims and had no reason to hate them – he just enjoyed killing people.

It had been Smith's idea for them to travel from Dublin to London for the coronation, together with two girls they, or at least Smith, was trying to impress. They came by ferry to Liverpool, where they left one of the girls, for reasons unknown, before travelling on to London. Once in central London, they took the Northern Line to the area around Tooting and Tooting Bec, where friends who worked in London as navvies assured them there was plenty of cheap accommodation within easy reach of the city centre. They checked into a room and left their bags, before returning to Tooting Bec Underground Station. As they waited for the train back to the city centre, Kelly clearly recalled Smith saying to him: 'Hey Kelly, you're 30 now. It's about time you got married.' Kelly was actually only 23-years-old and why Smith thought Kelly was 30 is unclear. The comment was probably innocent enough and seen as something of a joke but Kelly immediately saw red.

Repeatedly during his confessions, Kelly said that on hearing Smith's innocuous comment, his world collapsed. He believed that Smith was letting him know, albeit in a

subtle way, that he knew Kelly was hiding a dark secret and that rather than be the marrying type, Kelly, was a closet homosexual. He could not understand what had given him away. He had of course, been careful to conceal the truth from family and friends, to the extent that his bedroom was littered with girlie magazines, 'hidden' from sight in such a way that his mother would find them and think her son was a red-blooded young man with an eye for the ladies. How did Smith know? Who else knew? Kelly went into blind panic. His whole body shook. He had difficulty breathing. He was unable to concentrate. He struggled to come to terms with what had happened, why it had happened and what he needed to do to resolve the situation. He considered the consequences if his father, mother, brothers, sister, school friends, workmates, drinking mates or anybody else ever found out the truth about his homosexuality. He considered killing himself until he decided instead to kill his best friend.

Kelly followed Smith all over London that day, catching glimpses of the coronation on various televisions, attending street parties, drinking heavily, chatting up women and despite appearing to enjoy the celebrations, he was in reality unable to focus on anything other than the fact his secret was out and that he was doomed. Life as he knew it would come to an end when people found out his secret. He considered his options: he could move abroad to Australia, New Zealand or maybe America. He could hope to lose himself in London or another large city. Dublin and even Ireland were ruled out for being too small. He would soon be discovered there. He thought about suicide. He could throw himself under a car or maybe under a train. Maybe he could take an overdose. Hanging was out the question as the digs were too busy and he'd surely be disturbed. The crazy ideas continued to circulate around his head.

Late that evening, already worse for wear, Smith and Kelly picked up two 'brasses', or prostitutes and arranged to take them back to their room in Tooting Bec. Kelly had no interest in either of the women, but knew that if he were

to persuade Smith that he had made a terrible mistake in accusing him of being homosexual, he had to put on a good show with the woman of the night.

Around midnight Kelly was standing with Smith and the two prostitutes on the Northern Line platform at Stockwell Underground Station waiting for the last train back to their digs in Tooting Bec, when he heard a loud noise. He realized it was the sound of the train approaching and as he looked up and saw a bright light, he felt as if he was experiencing an epiphany. Suddenly, he realized what he had to do and without hesitation he pushed Smith under the train. Launching him on to the tracks to be hit by a tube train at speed was, as Kelly said, like pushing Smith through a mincing machine. There were blood and guts everywhere, just like a scene from a horror film.

The two prostitutes panicked and ran out of the station. They knew if they stayed they could expect to spend the next couple of days at the local station answering questions about what the two men – perpetrator and victim – looked like, what they knew about their backgrounds, how they had met them, where they were going at the time of the incident and much more. The women knew the police would have a low opinion of them and would most likely question them about their own line of work. It was highly likely that after providing eyewitness statements for the police, they would also receive some sort of punishment themselves. It all sounded very unattractive so off they went. There were no CCTV cameras in those days and the women were never seen again or ever identified. They are probably old-age pensioners now, living with their secrets and barely giving a thought to that gruesome incident from all those years ago.

Passengers on the train and people in the platform reacted in a similar manner. It was late at night after a day of national celebration and most of the people out at that time had probably had too much to drink, or had dabbled in some illegal drugs, and certainly didn't want to talk to the police. They did not know the man who had been killed

and for all they knew, it was probably a tragic accident anyway. He wouldn't have been the first person to slip and fall under a tube train after a drink too many. If there were any eyewitnesses, they fled the scene as quickly as they could. The British Transport Police had been formed just five years earlier in 1948 and by the time they arrived, there would have been a body under the train, a distraught train driver and possibly an ambulance crew waiting for permission to remove the deceased. The police would have conducted a quick look around and a search of the victim's pockets for any identification, filed a report to the Criminal Investigation Department (CID) and police duty officer and sent the body off to hospital where death would be certified.

Kelly, meanwhile, didn't hang around. As soon as he tipped Smith over, he ran out of the station, constantly looking over his shoulder. He fully expected to be arrested at any moment and then, after a quick trial at the Old Bailey, be taken away and hanged. That's what happened to murderers in 1953. It would be another 12 years before the death penalty was abolished for murder in Great Britain. If he were lucky he would get to spend the rest of his life in prison.

Fearing the police would have been patrolling the tube network in an attempt to find their crazed assailant, Kelly had walked back from Stockwell to the room he and Smith had been sharing in Tooting. It took him nearly four hours to make it back to his temporary accommodation. He had drunk so much that he had staggered home and with only scant knowledge of the London streets, had made the occasional wrong turn. As soon as he got back, he fell asleep. In the morning he woke early and every time somebody walked past the house or rang the doorbell, he jumped, convinced that his time was up and that he was going to be dragged off to the local police station.

In the days that followed, Kelly was in turmoil as he struggled to come to terms with what he had done and what the inevitable consequences would be. Every police

car he saw from his window and every policeman he witnessed walking down the road was chasing him, or so he thought. Every bell he heard (police cars had bells and not sirens or two-tone horns until 1965) was a sign they were searching for him. What should he do? Where should he go? Who could help him? He stayed in the room for a week or two. It gave him a chance to try and understand what had happened and why he had done what he had done. His mind raced as he tried to make sense of what the future held for him. His landlord couldn't understand why he never left the room, even to buy food or drink. And what had happened to his mate? Why had he not returned after their night out? The landlord told him not to expect a refund just because his mate had gone off with some bird that he had picked up in London. Kelly didn't fight it. He had other worries and nothing was further from his mind than a refund for his absent friend.

Kelly knew that, barring miracles, his friend was dead. You don't get hit by a train at speed and survive and anyway he'd seen the spillage of Smith's innards. He was sorry for his friend but he was even more worried about himself. Who had seen what had happened? Did the two prostitutes know his name? What had he and Smith told the women about the two of them? He was so drunk he couldn't remember. Surely they knew Kelly's name. Surely they'd passed it on to the police. Kelly couldn't grasp what had happened and what had made him act that way. Why had he killed his best friend? They had been friends for years, since they were young lads. He couldn't understand why he had turned on him. It didn't make sense to him at all. He was also troubled by the way it had made him feel. He had enjoyed the kill. It had been exciting. Thrilling. He even got an erection from it. How did that work? More importantly he realized that by killing Smith, he had solved his own problem. Smith wasn't going to blurt out his homosexuality now was he? Kelly's secret was safe.

Trapped in the flat for fear of being arrested and with no alcohol to drown his sorrows, the pressure got to Kelly. He

stopped bathing, washing or shaving and his landlord lost patience with having this smelly scruffbag hanging around all the time, using up his electricity. Eventually, they both became sick of each other and Kelly, still baffled as to why he hadn't been arrested, packed his few belongings into his kitbag and decided to head back to Dublin.

For the next six months in Dublin, Kelly lay low. He constantly worried that one day there would be a knock on the door from a group of Garda officers, accompanied by one of their colleagues from Scotland Yard, waiting to take him back to London to answer murder charges. Yet miraculously, nothing happened and, bit by bit, Kelly got his confidence back and life returned to normal.

For the next few years, he lived quietly, found work and made a little money. Life as a labourer has its ups and downs. When times are good, there is always plenty of work and plenty of cash but when a recession hits, jobs go and it is difficult to make a fraction of the money you could bank on before. When work was hard to come by, Kelly stepped outside of the law to make ends meet: a little theft here, a burglary there, a mugging when the opportunity arose. A life of crime brought its own stresses and he dealt with them the only way he knew – he drank too much as it helped him to forget.

Eventually the inevitable happened: Kelly was arrested for drunkenness. He knew what that meant. He would have to give his name and address. His fingerprints would be taken. The police would check their files, realize that he was the murderer from Stockwell Underground Station and he would be charged, end up at the Old Bailey and be hanged. Yet, when the next morning he appeared in court, he was simply fined and released, Kelly was confused. Surely the police had identified him as the murderer? Surely he would be hanged?

Realizing he'd got away – literally – with murder, Kelly decided to celebrate with a drink with some of the alcoholics and vagrants he knew in Dublin. When the alcohol ran out, it was Kelly who volunteered to go to the local shop and

steal a few cans and it was he who was arrested. This time the judge was not as lenient and he was sent to prison for nine months. It was the first of many such convictions and sentences. Over the next 30 years, it wasn't uncommon for Kelly to complete a three-year sentence, have one day of freedom during which he was once again arrested and be sentenced to another three years. He was never out of prison for long before being sent back in again.

Despite his imprisonment in Ireland, Most of his criminal life was spent in London and Kelly quickly became a 'face' around the capital's prisons: Brixton, Wandsworth, Pentonville, and Wormwood Scrubs. There were few secrets between prisoners and although nobody informed the police of Kelly's murderous background, it was general knowledge inside that Kelly had killed and that he would probably do so again. Yet Kelly has never been charged with the murder of Christy Smith. If he had, maybe he woudn't have gone on to kill so many more.

CHAPTER 4

Kelly's Other Murders

K elly has been connected with 31 murders. He was arrested and acquitted eight times for eight separate murders by eight different police murder squads between 1953 and 1983. Then, in the interviews that followed his arrest in Clapham on 4 August 1983, he admitted to a further 16 murders. Finally, as a result of the publicity following my 2015 book, *The London Underground Serial Killer*, relatives of seven more people who fell underneath tube trains during Kelly's 30-year killing spree, came forward. They alleged that their loved ones may also have been murdered by Kelly. The officer in charge of the current re-investigation into his crimes believes 31 to be an accurate number.

Kelly's first murder was his best friend Christy Smith in 1953 and the final person to lose their life at his hands was William Boyd, who was killed in 1983, in the cells at Clapham Police Station. But what of the other alleged victims? Nine of these cases are discussed here. Five cases were admitted very late on in the investigation and are not included in the papers released by the National Archives. Details of these cases are very scant and have never been released to the public. Finally, details will be given of three of the seven cases to contact the police since the publication of my book. Details of the other cases have not been released to the public.

Following his arrest in 1983, Kelly told police that a decade earlier, in 1973, he was responsible for the death of a bearded old vagrant who lived in a block of derelict houses opposite the Tate Library in Vauxhall. He said that he hit the vagrant over the head with 'a bit of a bar' and then buried his body in the basement of the house. He

went on to state that the house was pulled down a little while later but the builders never found any trace of the body. As a result of Kelly's confession, detectives made enquiries in the area. Although they could find no trace of the incident, they confirmed that the houses he referred to were demolished around 1978. It was felt that without a body or any corroboration of Kelly's story, the matter could be taken no further and no charges should be brought against Kelly. However, police believed his claim was entirely plausible and this was confirmed in the case report.

Again in 1973, Kelly told police he went to Bournemouth, where he had 'used a knife' on an Irish tramp. He didn't think the man had died as a result of his injuries but could not be sure. Dorset detectives made local enquiries but could find no trace of a vagrant (or any other person) receiving knife wounds in the Bournemouth area around this time and confirmed that there were no outstanding murder enquiries of this nature. Not long after, in 1974, Kelly struck again but this time in London and his weapon of choice was his foot. Kelly confessed to approaching a vagrant in Shepherd's Bush and giving him a 'serious kicking'. However when he got back to south London he had heard – probably through the grapevine connecting the vagrant community – that the man had died. Once more detectives made local enquiries but were again unable to find any trace of such an incident being reported to the police or of a victim who resembled the description given by Kelly.

This next crime has got more substance and is based on the case report submitted by Detective Inspector Ian Brown in 1983. It may be compared and contrasted with the facts as reported by the judges at the Court of Appeal, following the trial at the Old Bailey in 1984 and the appeal court case in 1985, which is reproduced in Appendix One.

When, in 1983, Kelly confessed to the murder of Hector John Fisher at Holy Trinity Church, Clapham Common in July 1975, police quickly recognized it as an incident they

had investigated eight years earlier. Details given by Kelly in his statements were accurate and they included details that would only have been known to the killer. Kelly was therefore charged with Fisher's murder and sentenced to life imprisonment for murder at the Old Bailey.

The facts of the case are that at 7.40 am on Saturday, 19 July 1975, the lifeless body of Hector John Fisher (born 14 January 1913), a 62-year-old retired printer of 589, Wandsworth Road, Clapham, was found lying on a bench in the churchyard of Holy Trinity Church, Clapham Common. Fisher had run his own printing business until 1965 but the death of his wife had caused him to become a chronic alcoholic. At the time of his death he was well known in the Clapham area and although he lived in his own home, he was, to all appearances, a vagrant.

Fisher's body was found by Alfred Ayres, a civil servant who was passing through the churchyard when he saw the body slumped on a bench with blood dripping from a head wound. He called an ambulance and Megan Anne Shilling, an ambulance technician, attended the scene. Finding no signs of life, she placed a blanket over the body and called the police. Police Constable Denise Bartlett (now deceased) attended the scene and arranged for the police surgeon, Dr Michael Sear, to come. He examined the body and pronounced Fisher dead at 8.50 am. He made a preliminary estimation of the time of death at between five to seven hours earlier.

The pathologist, Dr Hugh RM Johnston, also attended the scene and carried out a preliminary examination in the presence of Detective Chief Inspector Kean (now retired), Detective Chief Inspector Hopkins (now retired) and the exhibits officer, Detective Constable Leon James. A full post-mortem examination was carried out later that day at 2.00 pm. As a result, the cause of death was determined to be stab wounds to the neck and chest. A number of injuries had been inflicted upon the deceased, caused by a blunt instrument such as a whisky bottle or a piece of wood. Pieces of glass were found near the body, some of which came from

a White Horse Whisky bottle. According to police practice at the time, a murder squad of detectives was formed immediately and around 25 detectives investigated the case under the supervision of a detective superintendent. They failed to identify the murderer but submitted a 524-page report on the case (reference CR201/75/184).

As part of their investigations into Kelly's confessions in 1983, the Clapham detectives studied the original file. However, they found that it contained little of assistance and decided to prove the case against Kelly by comparing the answers given by Kelly during his interviews with statements taken at the time and subsequent to Kelly's arrest. During those interviews, Kelly revealed a detailed knowledge of Fisher's habits. He also gave the police facts that they thought could only be known to his murderer. The statements taken by police support Kelly's account of this murder and corroborate his verbal admissions. Kelly was taken into Clapham Police Station on four separate occasions to be questioned in relation to the Fisher murder.

On 28 July 1975 a man who gave his name as Kenneth Kelly and his date of birth as 28 March 1931 made a statement at Clapham Police Station in which he said: 'Since the date of the murder I have been pulled in a few times by police.' Kieran Kelly was arrested some three weeks after the murder and on his arrival at Wandsworth Prison he supplied his date of birth as 28 March 1921 (some nine years before he was actually born). Although Kenneth Kelly is not identified as Kieran Kelly in the original docket, other documentation is available to suggest that both men were thought by police to be identical.

Kelly told police: 'I saw him [Fisher] in the fish and chip shop. He sat down and had something.' Demetrious Timothy, the proprietor of the Supreme Fish Shop at 15, The Pavement, Clapham and his wife Anastasia and daughter Maria, all state that Fisher regularly ate in their shop between 7.00 pm and 9.30 pm. They did not, however, recall him being there on the evening of the murder.

Kelly went on to tell police that on the night of the

murder, he had a disagreement with the proprietor of an off licence after he ordered three bottles of cider but was only allowed two, because he was a couple of pence short of the price. He told police that he had returned to the off licence the next day with money he had stolen from Fisher. Victor and Ann Pearson were the managers of Davidson's Off Licence at 5, Old Town, Clapham, at that time and they made statements stating that Fisher regularly bought a half bottle of White Horse Whisky. They also described an incident in which Fisher, who was usually alone, came into the off licence with an Irish man, who after taking cider from a shelf, told Fisher to pay for it, which he did.

In further statements taken from them both on 23 August 1983 they recalled an incident timed by Mrs Pearson as occurring at 5.40 pm on Thursday, 17 July 1975 when the Irishman who had previously been with Fisher, came into the off licence and an argument ensued over the payment of a third bottle of Strongbow cider. She couldn't remember the exact amount, but stated that he was short of a few coppers. Neither Mr nor Mrs Pearson could recall the man returning the following day and said they had not seen him since. There was some discrepancy over Kelly's physical appearance with Mr Pearson claiming the Irish man was 'a big well-built man' whereas Kelly was slight and slim.

In his confession, Kelly said that he followed Fisher across the common and then 'walloped him across the head first with a metal bar'. This was changed later to 'a closed heavy knife', which had a six-inch blade and was old and hard to open. The pathologist, Dr Johnson found evidence of a blow to the head with a blunt instrument, which he stated could possibly have been a whisky bottle although no glass fragments were found in Fisher's skull. Kelly told police that he had then stabbed Fisher a number of times all over his body but especially in the 'bollocks' as he put it, 'because he was a dirty old cunt', and also alleged that 'he dressed up in women's clothing.' Although there is evidence to suggest that Fisher was homosexual, there is nothing to say he was a transvestite.

Kelly said that he had robbed Fisher of £30 or £40 in cash but had then replaced £15 to £18 of it. Dr Johnson stated that during his examination of Fisher at the scene he removed £15 in notes from the inside right breast pocket of Fisher's jacket. Victor Pearson confirmed that Fisher always had a wad of money in his pocket.

Kelly told police that he had seen police officers attend the scene and deal with Fisher's body on Saturday, 19 July 1975. He told them that he had been concerned as he had Fisher's blood on his clothing at the time. He said he met a man he knew as 'the colonel' on Clapham Common and asked him for a change of clothing. The man agreed and took Kelly to his home where he supplied him with a complete new set of clothes. Kelly went on to tell police that the old clothes had also been paint stained, presumably from painting and decorating and casual labouring that Kelly had been doing at the time. Kelly said the colonel lived within 100 yards of the common and that he and his wife were antique dealers.

Police identified the colonel as George Edward Joseph Horan of 4, Orlando Road, Clapham. Horan confirmed that he had supplied a man he knew as Jimmy with a change of clothing but no date is mentioned in his statement. Horan, however, attended Clapham Police Station on 23 July 1975 where he identified Jimmy as being Kenneth Kelly. He further identified the clothing worn by the accused as the clothing that he had given him. He also mentioned that the old clothes had been streaked with paint and were so scruffy that they were taken away by the dustmen. Asked why he'd agreed to provide 'Jimmy' with a change of clothing, Horan said he had told him that he was going for a job and he felt he should be given a chance in life.

Kelly told police that the bench in the churchyard, upon which he had murdered Fisher, had since been removed. After revisiting the scene and making enquiries with Lambeth Council, police confirmed this was true. It is interesting to note that when Kelly was arrested on 3 June 1977, two years after Fisher's death and just three days

after he had committed another murder, he was sitting on the bench on which Fisher had been killed.

The only weakness in the case against Kelly was the discrepancy between Kelly's version of events in the chip shop and off licence, which he said occurred on Friday and the proprietors' versions which state the events occurred on Thursday. As the pathologist's report on Fisher's stomach contents concluded, it is unlikely that Fisher ate fish and chips some six hours before his death. It would seem more likely that these events occurred on the Thursday. However, Kelly was frequently drunk and this affected his memory and led to confusion over times and dates. In fact, Kelly's inability to recall exact times and places dogged the entire enquiry. Nevertheless, it was felt that the overwhelming circumstantial evidence coupled with his repeated admissions strongly supported him being charged with the murder of Fisher. In the middle of 1984, he was convicted at the Old Bailey and sentenced to life imprisonment. Despite his earlier confession, Kelly appealed, implying that the story had been forced out of him but a year later, the Court of Appeal dismissed this. During the appeal it was suggested that the off-licence owner, Mr Pearson who had given evidence for the prosecution at the time, should now give evidence for the defence, as his description of the accused as a well-built man did not fit Kelly's own physical appearance. However, this was not allowed. The full judgement of the appeal is reproduced in Appendix One.

According to Kelly, he claimed his next victim one year later in 1976. He told police that towards late evening, on a date he could not recall, he went to a flat owned by a man called Paddy Kelly. This flat had been a regular drinking haunt for vagrants and an old man whom he believed to be a seaman, had been in a drunken sleep on the floor. Kelly, for no particular reason, tied a rag around the man's head to keep it steady, rested the man's head on his knees, forced open the mouth and poured alcohol down his throat until he started to vomit. To corroborate the claim, Kelly

gave the names of other people who were present at the time and stated that the coroner, Sir Montague Levine, had brought in a verdict of accidental death, based on his assessment that the man had choked on his own vomit.

Enquiries reveal that an incident, almost identical in every way to that described by Kelly, took place at 129 Coronation Buildings, in a flat tenanted by Paddy Kelly, who also used the surname Barlow. A number of the vagrants named by Kelly as being present at the time were traced and taken to Kennington Police Station and questioned at length about the incident. Michael Brendan Flynn and John Christopher Doyle could not remember Kelly being present and Doyle was adamant that he was not there and told police that he thought he had been in prison at the time. The victim, known as Paddy Kelly, was identified as Patrick Anthony Walters, a 29-year-old tramp whose date of birth was 26 July 1946. The death had taken place on 15 April 1976.

As was so often the case with Kelly's confessions, some things just didn't add up. A check of his criminal record revealed that Doyle was right and on 15 April 1976, Kelly was serving a two-year sentence at Wandsworth Prison. The imprisonment had been imposed at Lewes Crown Court on 19 September 1975 and he had not been released until 18 January 1977. Kelly's prison file records no movements for him on that day and it can safely be assumed that he did not leave the confines of the prison walls.

There was further confusion when a photograph of Walters was shown to Kelly shortly after his confession. When asked if he knew the man Kelly said: 'He is a poof.' Asked if he had killed him, he said: 'No'. He added that he had seen the man in the photograph some two years earlier. Clearly, he didn't recognize him as the person he had claimed to have murdered in Coronation Buildings. In further interviews, it appeared that he was connecting an incident at which he claimed to have been present with a story told to him on his release from prison. There was no record of another assault of a similar nature taking

place. A full enquiry was made and it was considered safe to conclude that Kelly had not been responsible for Walters' death. In view of Kelly's history of acquittals and the allegations he made against the police, it was thought that he confessed in the hope the police would charge him with an offence that he could not possibly have committed. By doing so, it would discredit their reputation.

Another homeless man to die at the hands of Kelly, or so he claimed, was 55-year-old Edward Joseph Toal. On Tuesday, 31 May 1977 at about 7.00 pm Toal's apparently lifeless body was found in Kennington Park. He had been strangled and was found by a park keeper on a park bench near the Kennington Park Road entrance. Toal was a vagrant who regularly frequented the park and was known to be an alcoholic. He could be easily identified by the fact he had an artificial leg. He walked with a limp, relied on the use of a stick and wouldn't have been able to put up much of a fight with someone intent on squeezing the life out of him. Kelly stood trial for the murder but was acquitted (CR201/77/136).

Whilst detained in Brixton Prison awaiting trial for the Boyd murder in 1983, Kelly told his solicitor, John Slater, that he had been responsible for the death of a man called Micky Dunne in Tooting on 28 August 1982. Dunne had given evidence for the prosecution when Kelly stood trial for the murder of one-legged Toal as Dunne claimed to have been an eyewitness to the attack in Kennington Park. Over the years, Kelly admitted to killing several people who had witnessed him committing various crimes. He always used the same technique – feeding his victim white spirit or surgical spirit mixed with orange juice. In Dunne's case, Kelly added pills to the mix and handed him the fatal cocktail of surgical spirit, orange juice and pills. He said he sat down with Dunne on a bench and stayed with him until he had drunk it and then also gave him a 'bit of a beating'.

In his statement, Kelly stated that Dunne had been taken away from the scene to King's College Hospital in Camberwell, where he had passed away and cirrhosis

of the liver had been given as the cause of death. This is strange for two reasons. Firstly, people taken to hospital by ambulance from Tooting, are usually driven to St George's Hospital, just down the road, rather than to King's College Hospital, five miles away. Secondly, whilst Kelly could have hung around to see what happened to Dunne, it is difficult to know how a man with no home and no mobile telephone could have discovered where a man to whom he had no relationship had been taken by an ambulance, or that he had died and what had been given as his cause of death. However, this is a feature in most of Kelly's cases and he seems to have followed up on each and all of them. If Kelly was telling the truth, maybe he picked up the facts from others in the close-knit vagrant community. A murder of one of their own would have been big news and triggered much discussion.

Police enquiries following up on Kelly's statement identified that on 23 August 1983, five days before Dunne died, another tramp, John Joseph O'Conner, had been drinking with Kelly and Dunne on a bench by the library at Tooting Broadway from 8.00 pm until shortly before 11.00 pm. O'Conner then left to purchase more cider before the off licence closed. On his return he found that Kelly and Dunne had been fighting and that Dunne was bleeding from a cut cheek. Kelly then left the two men together and O'Conner and Dunne slept that night in a derelict house or churchyard. The following day, Dunne's leg was badly swollen and his stomach was distended. O'Conner helped him reach Camberwell Reception Centre so he could get help.

Dunne was examined by Dr John Christopher Hewetson, who noticed that he had abrasions around his face as well as a black eye. Dunne complained to him of being mugged. He was seen again on 26 August, when he complained of abdominal distension and discomfort and was admitted to King's College Hospital. He started to recover before taking a sudden turn for the worse and he died two days later on 28 August 1982. The pathologist, Dr William

Whimster examined Dunne on 2 September 1982 and concluded that he had died from broncho-pneumonia and cryptogenic cirrhosis of the liver. After hearing Kelly's side of the story, Professor Roger Williams, head of the liver unit at King's College Hospital, decided that the cocktail he gave Dunne may well have hastened his death and he wrote a report that was passed on to police. However, after a while, it was decided not to proceed further with the investigation and no charges were brought against Kelly.

Kelly could not, however, avoid being charged for the next crime as he committed it in public. One day in early 1983, three people (a doctor, a lawyer and an accountant) witnessed Kelly pushing Francis Taylor underneath a London Underground train at Tooting Bec Station. He was restrained physically until the police arrived and satisfied with the evidence given to them, the police arrested and charged him with murder. Kelly went on trial at the Old Bailey but, try as they might, the jury failed to understand how a man like Kelly 'who pees in bushes on the common' would want to murder a professional person like Taylor. In the absence of a plausible motive, the jury decided there was an element of doubt and found Kelly not guilty. Incredibly, considering the witnesses who had come forward at the time, he was freed and two weeks later he was arrested again for the murder of William Boyd.

It was while he was detained in Brixton Prison awaiting trial for Boyd's murder, that Kelly told his solicitor Slater that he had been responsible for throwing a man he knew as Jock Gordon on to the railway tracks at Oval Underground Station. Kelly was obviously in confessional mood as he also admitted to Dunne's murder at the same time. He told Slater he couldn't be specific about dates but it was between 18 July and 4 August 1983. It had occurred only days, if not hours, after his release from the Old Bailey on 18 July when he was acquitted of the murder of Francis Taylor. Miraculously, it looked like Gordon had survived.

Gordon was a drinker who, like Kelly, was familiar with the vagrant communities that socialized in the open spaces

of south London. Detectives realized that if they were to get to the bottom of this investigation, they would have to infiltrate these groups and I was dispatched to make contact with them. To do this, I left off washing for a while and brought a bottle with me to ingratiate myself with the group of which Kelly – or 'Nosey' as he was known due to his long, curved, beak-like nose, which with his large, staring eyes gave him the look of a hawk or an owl – was part. I lived with them for a while, sleeping rough on Clapham Common, Camberwell Green, Kennington Park and Tooting Bec. Occasionally I won a bed for the night and stayed at Rowton House in Vauxhall. I supplied cider, sherry, strong lager and shoe polish to my new 'friends' and unsurprisingly, was welcomed with open arms. Very soon I became privy to mutterings about Kelly pushing a man under a train at Oval Station. Apparently, the victim was drunk at the time and, possibly because of this, he had lain flat between the two rails and allowed the train to go over him. All the other victims had been killed and, as a result, were no longer available to give evidence. This man could still be alive and be a valuable witness.

However, when I made enquiries at Oval Underground Station, no incident report could be found and no member of staff admitted knowing about it. Apparently, the station manager, worried that he might lose his job for allowing such a crime to happen on his turf or possibly believing the victim to have fallen drunkenly from the platform, took the matter into his own hands by giving him a firm slap and throwing him out of the station. Rough justice for a man who had narrowly escaped death.

Armed with the name Jock Gordon, an approximate address near the Oval, and the fact that he was Scottish, was enough to take me to the Department of Social Security offices in Marshalsea Road. Just half a mile south of London Bridge, this office dealt with all homeless claimants in the UK and retained the fingerprints and records of everyone on their books. They were able to identify Jock Gordon as Gordon McMurray and confirm his address. A few days

later, while making a statement regarding the Dunne incident, O'Conner also confirmed that Jock Gordon was indeed McMurray.

McMurray was 60-years-old and had spent the last 30 years of his life as a vagrant, mixing with other homeless groups who moved between Kennington Park, Camberwell Green, Peckham Rye and Clapham Common. For much of that time he had known a man he knew only as 'Nosey' and when drunk, they would fight and inflict quite serious injuries on each other – injuries that would not hurt until days later when they sobered up.

His memory leading up to the incident at Oval was hazy and affected by the fact that they had been drinking together for several days. He was unable to recall exactly what the argument had been about, but it had developed into a fight and he clearly remembered 'Nosey' pushing him under the Northern Line train. This was where his memory suddenly improved. Clearly, the recognition that he was in serious danger helped him sober up. Although he didn't know what to do for the best, he made the split-second decision to lie flat between the tracks under the train until after a few minutes, it drove away from the platform. A crowd quickly gathered around him and the station staff was summoned. The station manager helped him back onto the platform but then launched into a tirade, slapped him around a bit and escorted him out of the station. No record of the incident could be found in any London Underground or BTP file. Clearly, the station manager was worried that this incident would reflect badly on his staff and he simply wanted it to go away. McMurray had then made his way home to sleep off the drink and the drama.

He repeated these details in a statement made at Kennington Police Station, a place he knew well having been taken there just a few days earlier following his arrest for being drunk and incapable. He said he would be happy to attend court and give evidence against 'Nosey' as despite knowing each other for decades, Kelly and McMurray had no idea of their actual names. For this reason the director

of public prosecutions demanded the police held an identification parade to ensure that the man that he knew as 'Nosey' was the same man the police knew as Kelly. The law requires that an identification parade should consist of people of similar height, weight, build and appearance, with back ups in case of any objection by the suspect or his legal team. It was held at Cedars Lodge, a homeless hostel on the north side of Clapham Common near Clapham Junction Station, and it was conducted by Inspector Christopher Gausden.

As the residents were usually required to vacate the premises after breakfast, arrangements were made for the parade to take place at 11.00 am. Prior to that, police officers appealed for those living there to take part in the line up. Aware they would be paid for their time, 20 men, who resembled Kelly in height, weight, build and appearance, signed up. During an identification parade, it is essential to secure the members' names, addresses and dates of birth. However, as these men were of no fixed abode, their criminal records were checked so they could be identified and traced should that be necessary for the trial. As they had all been arrested frequently for drunken behaviour, every one knew his own criminal record office number, having heard it recited on numerous occasions.

Kelly's legal team were shown the room in which the parade was to take place, so that they could check that it was suitable for the purpose, with adequate lighting and sufficient doors to allow access and egress. It was essential that the line up and witness could enter the room without seeing each other beforehand. The team had no objections and were led out so the men could be brought in. Each man was given a cup of tea, slice of cake and a £5 note. Police regulations require a receipt from each of the recipients but as several of them were not able to read or write, there was a long list of Xs in place of signatures. Having been fed, watered and most importantly paid, the 20 men were happy to stand in line as Kelly's legal team came back into the room to ensure that they were happy with the police's

selection. Objections were raised about three men who were duly escorted from the room but as they were allowed to keep their £5 note they failed to argue with the decision.

At this point, Inspector Gausden, who was conducting and supervising the parade, entered the room and took charge of the proceedings. He confirmed the selection of the room, the routes to be taken by each party, and then left to go to the ante-room in which Kelly's legal team had been placed, to confirm their agreement with the arrangements. The only thing that was missing was the suspect.

Kelly was in Brixton Prison, having been remanded in custody for attempted murder. He was a Category A prisoner. This meant that he was seen as a danger to the public and if the home secretary enquired about him, the governor of Brixton Prison had to be able to give Kelly's exact location at all times. Four officers in a prisoner transport vehicle had been dispatched to Brixton Prison to collect him and deliver him to Cedars Lodge. When they arrived they remained in the van and used a local radio to call Inspector Gausden to secure their instructions. He had Kelly delivered to the room and arranged for his legal team to join him there.

Eleven of the 17 remaining candidates for the parade were lined up and reviewed both by the police inspector and Kelly's legal team. Kelly was then invited to join the parade and told he could stand wherever he wanted. He chose a spot in the line and the other men shuffled along. McMurray was then delivered to the room and asked to look along the line to see whether the man who had pushed him under the train at Oval Underground Station was present or not. He took one pace forward, immediately recognized the man who had tried to murder him and punched him squarely in the face. As Kelly hit the floor, the men who made up the rest of the parade turned on him and started to kick and punch. For some it was a rare chance to get their own back on a man who had ruled the vagrant community by hurting and killing others that got in his way while maintaining a position of power due to

his ability to steal alcohol from shops and keep the group supplied with refreshments. Inspector Gausden stepped forward with the intention of stopping the brawl but at the same time, he hoped to complete the formalities of the parade so he could nail his man. Doing his best to be heard above the commotion, Inspector Gausden asked, rather unnecessarily: 'Is there any doubt in your mind? Are you certain that this is the man?' It took 15 minutes to stop the fight. Eventually, all the police officers and all the social workers in attendance at Cedars Lodge had to step in to separate the parties.

Having positively identified Kelly, it looked like an open and shut case. However, McMurray started to get cold feet and told police he was frightened of the consequences of giving evidence against him. He wanted police protection. Even though Kelly was in prison, awaiting trial, he had many friends among the vagrant community who might want to do him a favour and could track McMurray down in an instant. So, it was decided that rather than stay in his own flat, where he didn't feel safe, he could stay at Kennington Police Station for as long as he wanted. Upstairs there was a set of unused cells that were retained for public order emergencies and here McMurray remained for almost a year. It was a comfortable set-up with his own television and three meals a day. And of course, living with the law meant he was perfectly safe from any attempts of revenge or retribution.

However, in the final days before the court case, McMurray became increasingly stressed and asked to leave the station. As a free man, police were obliged to let him go although they were concerned that he might never come back. Fortunately, he was found in time to appear at court and give his evidence. Without the support given to him by the police, McMurray would not have been available to give evidence of the major crimes he had witnessed of which the courts should have been aware. The police took the action that they felt was necessary to deliver valuable witnesses to the court and to allow them

to freely and openly provide the evidence that they had in their possession to the court. No attempt was ever made to influence McMurray. The defence never asked about the support offered to him as a witness and no lies were ever told about it. Some of their efforts to secure an acquittal for Kelly were far more questionable than anything done by the officers. Such is the nature of our criminal justice system. Kelly was charged with the attempted murder of McMurray but twice the case went to a mistrial as the jury couldn't agree on a verdict.

In July 2015, three women contacted my publishers to say they, or their relatives had been pushed under London Underground trains. They had been compelled to get in touch after reading press reports about Kelly, which had been written in response to my book *The London Underground Serial Killer*. Although not all of them named Kelly as a possible attacker, they had many unanswered questions and it is fair to say they all wondered if Kelly had been involved in some way.

Helen McIntyre explained that her brother James Walker, who was born in Camden, north London on 29 October 1954, had been pushed underneath a London Underground train while travelling from St Pancras to Embankment on an unknown date in January 1979 at 7.00 pm. I visited her in Scotland when she told me that even after all these years, not knowing was tearing her apart. She said:

'We don't know what happened to my brother. Maybe he did fall. Probably we'll never know. When my younger sister, who was 21-years-old at the time, went to identify my brother's body, she overheard one of the men who had been at the scene dealing with the accident say: "We've got to get this right. We can't afford to let ourselves get tripped up."

'I called up to find out what had happened to my

brother and I was put through to an administrator. Without checking, she immediately told me that they didn't have the files, that they had been destroyed in an accident. I tried to get the autopsy report but was told that it wasn't available. I thought that those reports were meant to be on microfiche forever. I just want to know what happened to my brother. All my family want to know what happened to him.

'My brother was a homosexual. I have done everything to contact his partner since his death, but I can find no trace of him anywhere. He completely disappeared as soon as my brother died. I wonder if he knows anything or if he is just another victim, struggling to cope. My mother and older sister just cannot think about my brother and what happened to him. My younger sister was asked to identify her brother. She was only 21 and was troubled by what she saw had happened. I am different, I just want to know.

'I contacted you through your publisher. It hit me that this could be something. Maybe this is what happened to my brother. One witness said that he saw a man push my brother under the train… We all want to understand what happened to my brother. He had won the football pools a few days earlier. Why would he want to commit suicide?

'I want to understand why there is this cover up by the government? Why won't they let me see my brother's post-mortem report? Why will nobody talk to me about his death? People have got to get closure for cases like this. There seem to be cover-ups everywhere I look. I think that there's a lot more to it than they are saying. I just keep feeling that my brother could still be alive today.'

Another woman to contact me, Maeve Weller, reported that she herself had been pushed underneath a Northern Line tube train. Although we discussed the case at length, she declined to supply me with the date, time or place of the incident, preferring to discuss it with the current BTP's major investigation team. By April 2016 she had spoken with the team just once, but hoped to speak to them again soon.

Finally, Teresa Lyons emailed me for advice on how she could report the death of her father, who had been pushed underneath a train on the Northern Line. With her consent, I forwarded his name, along with the details of all these potential victims to Detective Superintendent Richardson from the BTP.

Kelly's Final Murder

In August 1983, Kelly was 53 and had been living in south London for 23 years. When he wasn't detained in prison, he resided in the commons, parks and open spaces of south London, where he survived on petty theft, mainly shoplifting. He was known to the police as a vagrant with a long criminal record and, now well into middle age, he was as active a serial killer as he ever had been. Nothing was going to stop him unless he was caught and locked up for a very long time, if not forever.

Kelly's final victim was William Boyd, a 54-year-old Glaswegian alcoholic vagrant, born on 18 December 1928. He lived in hostels in south London and on the day of his death was staying at The Shelter at 35 Bondway on the south side of Vauxhall Bridge. He had paid a week in advance and had one week's bed tickets in his pocket.

Boyd's parents were well educated and they had high ambitions for their son. They sent him to Holy Cross Roman Catholic Primary School in Glasgow from the age of five to 11 and to St Mungo's Academy from 11 to 17. He was a bright student and earned a place at university, where he studied for a bachelor's degree until National Service intervened and he swapped study for the military at the end of his first year. He served in the Royal Corps of Signals, attained the rank of corporal and at the end of his service, his character was assessed as 'good'. On leaving the Army in November 1950 he secured employment as an articled clerk with JW Jarvie and Co Ltd of Glasgow but failed his chartered accountancy examinations.

Between 1955 and 1967 he worked as a senior audit assistant with four companies for periods of five, three, two and two years respectively, firstly in Glasgow and then in

London, where he first arrived in 1960. His last known period of permanent employment began in August 1968, when he worked as a senior audit assistant with accountants Febeson & Arbeid in London, on a salary of £1,100 per annum. Until 1973, he worked as a clerk for limited periods although there is no further record of employment. It is unclear how he moved from gainful employment to living life as a vagrant and drinker, sleeping rough or staying in reception centres or hostels. For the two weeks preceding his death, he was sleeping at The Shelter and spending his days drinking in Clapham.

On Thursday, 4 August 1983 at 8.20 am, Acting Police Sergeant (APS) 735 'L'/005513 Susan Chessun, who was attached to Clapham Police Station, was patrolling Clapham Road in full uniform. As she reached the junction with Union Road and stood outside Dolby Laboratories she saw a man sitting on the footway leaning against the wall. Seeing there was blood on the man's face and hands she spoke to him and when the man replied APS Chessun noticed that his breath smelt of intoxicating liquor and that his speech was slurred. Realizing he was drunk, he was arrested and taken to Clapham Police Station in the station van that she had called. He arrived there at 8.40 am.

In 1983, Clapham Police Station was a large Victorian corner house situated on the south side of the River Thames between Vauxhall and Wandsworth bridges. The working day was divided into three shifts: early turn, from 7.00 am to 3.00 pm, late turn from 3.00 pm to 11.00 pm and night duty from 11.00 pm. to 7.00 am. On an early turn, the station officer – who was in charge of the police station – would check all the prisoners with the night duty station officer to make sure they were fit and well and that he or she was in possession of all the relevant information about their cases. As there could be as many as 20 to 30 prisoners in custody after a busy night duty this could take the best part of an hour. Then the prisoners would be expecting breakfast and a cup of tea and some might even be hoping for a quick wash. Then it was time to send all the

Clapham Common and Clapham Old Town at The Pavement. The place where Kelly was finally arrested.

Clapham Old Town and Clapham Common at The Pavement. The place where Kelly was finally arrested.

The former Clapham Police Station – scene of Kelly's final murder in the cells. 51, Union Grove, London, SW4.

Kennington Police Station – where the witness, Jock McLintock, was kept before the trial.

The former South Western Magistrates Court (now Lavender Hill Magistrates Court). This is where Kelly appeared each week for remands in custody.

The former Lambeth Magistrates Court on Renfrew Road in Kennington, where Kelly's committal to the Old Bailey took place.

ilmour Section House opposite Lambeth Magistrates Court on Renfrew Road in Kennington.
he place where the witnesses were taken to clean up before the committal.

The Central Criminal Court at the Old Bailey, London, EC4, with its famous bronze statue of Lady Justice at the top.

Kennington
Underground Station.

Oval Underground
Station, with the
Oval Cricket Ground
in the background o
the right.

Stockwell Underground
Station – where it all
began in 1953. Of course
Stockwell has its own
serial killer – Kenneth
Erskine – but he started
after Kelly had been
stopped, and he 'only'
murdered seven people
between April and July
1986. The station is also
famous for the shooting
of Jean Charles de
Menezes by the Police in
2005.

Clapham North
Underground Station.

Clapham
Common
Underground
Station.

Clapham South Underground Station.

Balham
Underground
Station.

Tooting Bec
Underground
Station.

Tooting Broadway
Underground
Station.

Colliers Wood
Underground
Station.

outh Wimbledon
nderground
ation.

Morden
Underground
Station.

All three Clapham Underground Stations, Clapham North, Clapham Common and Clapham South, have a shared platform for northbound and southbound passengers. The one at Stockwell has been replaced. They increase the risks of falling underneath trains and plans are progressing for their removal.

When Charles Holden designed the Underground Station on the southern branch of the Northern Line, he incorporated these impressive lights that remind passesngers of the Moscow Underground, although the London Underground designed them first.

The Charles Holden Public House opposite the South Wimbledon Underground Station one of his proud achievements.

charged prisoners off to South Western Magistrates Court in Battersea.

When APS Chessun brought Boyd in, she gave all the facts to the custody officer – whose sole responsibility was to supervise the prisoners – who had him searched, authorized his detention and placed him in cell number three. This would have been shortly after the prison van had taken all the night-time detainees to court and Boyd would almost certainly have been the first person in the cells for the new daily cycle. Due to the blood on his face and hands and the fact he was exceptionally drunk, the police surgeon was called to examine him, arriving at 9.25 am. In his report, Dr Gerald Jerome Grainger stated that he had found Boyd to be very drunk and that he had cleaned a laceration to his right index finger and stuck a plaster on it. In accordance with the regulations he then checked Boyd over and found that he had no other injuries. At the end of the examination, Boyd was returned to his cell, where at 12.30 pm he was charged with being drunk in a public place by Police Sergeant (PS) 81 'L' Clifford Davis. He was detained in custody pending his appearance at court the next day.

Meanwhile, at about 1.30 pm that day Walter Laurence Bell, a 75-year-old retired tailor, left his home at 86, Stockwell Gardens to walk just under a mile along Clapham Road to Clapham High Street. Since retiring from work a couple of weeks earlier, he had taken to rising late, partaking of the afternoon sunshine and enjoying a pint of beer for lunch. When he arrived at the Royal Oak Public House at 10 Clapham High St, Bell made his way to the seats on the paved area opposite, where he sat for a couple of hours, reading his newspaper and drinking his beer. As he sat there enjoying his solitude, two men approached him. Bell described one, who was later identified as Kelly to be 5ft 8ins tall, of medium build, with black hair under a woolly hat and scruffy clothes. He appeared to be drunk. The other man was a fellow vagrant called Paul McManus. Subservient and compliant, he was a follower of Kelly's

who feared his own life might be in danger if he didn't simply do as he was told.

'Hey you're a good looking guy,' said Kelly. 'Fancy a fuck?' Bell was shocked. 'I'm not like that,' he replied. 'I'm a happily married man.' Kelly changed the subject. 'That's a nice watch,' he said. 'Give me your watch.' Bell refused. 'This is my watch. I'm not giving it away.' 'And the ring,' added Kelly. 'I'll take the ring too.' Bell was taken aback. 'This is my wedding ring. I'm not giving that away. My wife would never let me back into the house if I gave that away'. Kelly lowered his voice. 'Either give me your watch and your ring or I'll give you a kicking.' The old man looked around and believing that no one in the pub would help him if he were attacked, decided that he wouldn't make a fuss. He didn't put up a fight when Kelly twisted his frail arm behind his back and removed the gold ring from the little finger of his left hand. Quickly Bell took off his watch and handed it over to Kelly. While McManus said nothing but simply loitered next to Kelly, the commotion hadn't gone unnoticed and resulted in someone calling the police.

At about 4.30 pm, Police Constable (PC) 187 'L'/ 180159 Gerard Beith and PC 210 'L'/ 180187 William Fox, both attached to Clapham Police Station, arrived at the scene. They listened to the allegations made by Bell in the presence of both Kelly and McManus and then took the two accused behind some trees for privacy and searched them both, finding nothing. They questioned Kelly and McManus but the pair had been in the game for far too long to admit anything. Bell remained adamant that they had just taken his ring and his watch although there was nothing on the suspects to prove this. However, checks on their radios had revealed that Kelly and McManus were well known to the police and had a history of stealing. As a result they were arrested on suspicion of theft.

Kelly and McManus were taken, together with Bell, to Clapham Police Station, where they arrived at 4.50 pm. At this time, the custody officer was Police Sergeant 96 'L'/ 172212 Christopher Lynch who was being assisted

by PC 834 'L'/ 181135 Patrick Myhill as jailer. I was in the custody suite as were two young detectives, Detective Constable (DC) 187955 Russell Day and PC 541 'L'/ 170561 Christopher Mansfield. They were dealing with a man arrested for robbery and spent several hours with him in the photographic room. The station was busy and many other people were milling around.

Lynch was one of the new sergeants promoted to deal with the consequences of the Police and Criminal Evidence (PACE) Act of 1984. PACE, which was made law in early 1983, set out to strike the right balance between the powers of the police and the rights of the public. It demanded that, whenever prisoners were detained, there must be a separate station officer and custody officer rather than one person fulfilling both roles. It also required all officers to receive training in their new duties and responsibilities. Consequently, Lynch had recently completed a four-week course at the Metropolitan Police Training School in Colindale near Hendon in north London and was now starting his first tour of duty as a sergeant.

On arrival that morning, Sergeant Lynch had met with the chief superintendent and been told that he would be working as custody officer. Dutifully, he checked the prisoners, gave them breakfast and a wash and sent them off to court. Then he settled down in the empty custody suite to enjoy his own breakfast. It was just after this that he had received Boyd, following his arrest for drunkenness. It was Lynch who instructed him to be placed in a cell to sober up.

When Kelly and McManus arrived at the station, they were also dealt with by Sergeant Lynch. He heard the facts of the case from the arresting officers, Beith and Fox and realizing that possession of the ring and watch were essential to proving the allegation of robbery, authorized them to take Kelly and McManus, in turn, into an empty cell to be strip searched. Again, nothing was found. Sergeant Lynch then authorized their detention and instructed PC Fox and PC Myhill to place them in a cell. Because all the cells had

become occupied during the day, they were placed in cell number three, along with Boyd. The time was 5.15 pm.

Kelly and McManus were now the responsibility of DC Day who left them briefly with PC Mansfield while he spoke to Bell about the alleged robbery. Bell told him he was afraid that Kelly would track him down and assault him. He was also concerned that he would not be believed in court as the ring and watch had not been found. With this in mind, he decided to withdraw his allegation and made a statement to this effect. With Kelly and McManus no longer suspected of robbery, it was decided to charge them with being drunk and disorderly instead.

A little before 6.30 pm, just over an hour since Kelly and McManus had been brought into the station, Sergeant Lynch heard shouting coming from the cell block and sent his assistant, PC Myhill, to see what had happened. As he approached cell number three, Myhill heard McManus shout out: 'Call a police surgeon and save this man's life.' Myhill opened the wicket – the window in the cell door which allowed police staff to see what was happening in the cell – and saw Boyd lying on the floor. He called Sergeant Lynch, who hurried to the cell and arrived as McManus shouted: 'Let me out of here.' After checking in the cell and seeing Boyd, he opened the cell door to hear McManus say: 'He's a fucking psychopath.'

Sergeant Lynch turned Boyd over, saw that his face was flushed and that he had blood on his right temple. Realizing he was not breathing, he commenced mouth-to-mouth resuscitation and noticed as he did, that there was a tissue in Boyd's mouth, which he removed. With the alarm raised, DC Day and PC Mansfield rushed to cell number three to assist Lynch who was covered in the victim's blood. As Mansfield started giving Boyd chest compressions, Day removed the other prisoners and separated McManus and Kelly. All hands were on deck and I spoke to Kelly as he was being moved to cell number one, which already housed rape suspect Richard David Johnson. Having called an ambulance, the other officers continued working

on Boyd for 15 minutes, until it was obvious he could no longer be saved. PS Lynch was particularly overwhelmed by his death and kept on returning to the cell, refusing to believe that Boyd had gone. For a brief period, amid the confusion, it was thought Boyd might have died from natural causes, although the condition of his body and McManus's comments quickly convinced them otherwise.

Kelly was clearly agitated when he was placed in the cell with Johnson. According to the suspected rapist, Kelly admitted to assaulting Boyd but told him: 'He'll be alright.' A few minutes later, Detective Inspector (DI) Brian Bowden-Brown removed Johnson from the cell and took him to be interviewed about the rape. Before, he had denied everything but now he admitted to the crime and confessed to raping several other women, even providing names and addresses so they could all be identified by the police. The next day Johnson was charged and in due course went to court, where he pleaded guilty and was sentenced to life imprisonment with a recommendation that he serve a whole life term. Later on, he lodged an appeal against the conviction, claiming the police had deliberately placed Kelly in his cell to provoke him to confess. His conviction and sentence were upheld.

DI Brown was the senior criminal investigation department (CID) officer on duty and when DC Day reported the incident in the cell, he went there immediately to take charge. The exact time of his arrival was not recorded but he was there when the ambulance arrived at 6.50 pm and paramedic, Sylvia Davis, examined Boyd and found no signs of life. At 7.08 pm, Police Surgeon Dr Ian Alistair Smythe-Wood pronounced him dead.

It was around this time that Detective Chief Superintendent (DCS) Ray Adams arrived at the station, along with his deputy, Detective Superintendent Alan Jestico. DCS Adams summoned me to the charge room as he knew that I had a Nagra body tape recorder and he wanted to use it to interview Kelly. The Nagra (which means 'to record' in Polish) is used for covert surveillance

by law enforcement and intelligence agencies all over the world. It is a tape recorder of the highest quality and costs about the same as a car. The recorder is the size of a small packet of cigarettes and is taped to the body, usually in the hollow at the small of the back. I was instructed to get myself fitted up with the Nagra body tape as soon as I could and get back down to the cells. A few minutes later, having found a colleague to help me, I went to the cells, as instructed.

This time, the Kelly that I saw was a different person from the one I'd seen earlier. He swaggered through the station with every eye on him. He was taken into a small interview room and at 7.45pm the interview began. I stood in the corner out of the way. It was not my job to participate, just to provide cover for the Nagra.

During his interview, Kelly said Boyd had been lying on the cell floor alongside the passage wall, with his head towards the toilet area and his feet pointing towards the door. He said he sat down on the mattress next to him and Boyd had pushed him away. Kelly told officers that this had upset him and so he had punched Boyd about the head several times, drawing blood. He then removed his socks and used them to strangle him but he insisted it had not killed him.

The cell in which Boyd had died was then forensically examined and the exhibits officer, DC Turpie took possession of a pair of socks (exhibit MLT/1) and a pair of shoe laces (exhibit MLT/2), both knotted and found on the toilet seat. Bloodstained tissues were also removed from under the body.

Police Surgeon Dr Peter Green, examined Kelly and McManus at 10.10 p.m. In his report, he took swabs of smeared blood from both of Kelly's hands and said the injuries were consistent with a recent struggle. He reported no injuries to McManus, although he was described as being unsteady on his feet, with slurred speech and smelling of drink. Senior photographer Morgan Helps took photographs of the scene and later of Kelly and McManus.

The photographs of Kelly show fresh bruises and scratch marks on his left and right arm.

As McManus put it later, with three men in the cell at the time of Boyd's death, the police would quickly allocate one as victim, one as suspect murderer and one as star witness. With Boyd having cornered the role of victim, Kelly and McManus now had to fight it out for the other two roles.

When McManus was interviewed about the events in the cell, his story differed from Kelly's. He agreed that Boyd had been lying on the floor but he said he was mumbling continually, which Kelly found annoying and so he told him repeatedly to shut up. He added that Kelly had started off sitting silently in the toilet area but flipped suddenly and started kicking the cell door and demanding to be granted bail. He then lifted Boyd by his shoulders and put him on his (Kelly's) thighs. Kelly removed the scarf from around his own neck and wrapped it around Boyd's, adjusting it carefully before pulling on both ends and strangling Boyd. McManus said he intervened, telling him to leave Boyd alone until finally Kelly had slung the dying man on to the bench. McManus noticed there was blood on Boyd's face and Kelly started pacing the cell nervously. That's when McManus said he started shouting for assistance until police officers responded and came to the cell.

On hearing this version of events, instructions were made to find the murder weapon – the scarf that McManus claimed Kelly had used to strangle Boyd. The cells, the cell passage and the custody suite were all searched, as were Kelly and McManus yet no trace could be found. Nor could any of the arresting officers, custody staff or detectives remember seeing a scarf. McManus may have been mistaken but it didn't add to his credibility as a witness. It was Kelly's version of events that corresponded with the police officers' report on Boyd's injuries and would be corroborated with findings at the post mortem.

This took place the following day, Friday, 5 August 1983 at 12.15 pm at Southwark Mortuary. Professor of Forensic Medicine Arthur Keith Mant carried out the post mortem

and gave the cause of death as compression of the neck. He asserted that this had been applied with knotted socks and shoelaces. Formal identification of the body had not been possible due to the reluctance of John Boyd, the deceased's brother, to attend the mortuary. They had been estranged and had not seen each other for some 20 years. Although their parents were still alive they were both in their nineties and due to the circumstances and perhaps to shield them from the fact their son was a homeless alcoholic, John did not want them informed. Fingerprint identification of William Boyd was made by Mr Colton, a senior fingerprint officer, on 9 August 1983.

At 4.15 pm that day, Kelly was interviewed again, this time by DI Brown and DC Rod McMillan. DI Brown had struck up a close relationship with Kelly, asking after his welfare and always calling him by his nickname, 'Nosey'. Despite his seniority, Kelly had warmed to him, possibly because of his working class background (his nickname among police was 'Peckham Pikey'), Brown had no airs and graces and Kelly could relate to that. When he told Kelly the results of the post mortem and Professor Mant's determination of the cause of death, Kelly confessed to murdering Boyd. Without hesitation, he signed the notes of the interview that stated his admission that had been made by DC McMillan. As the officers returned him to his cell, he suddenly blurted out: 'Look I'm your man for this one, but now I've started, I want to tell you about some more that I've done in the past.' Kelly then admitted four further murders, dating back to 1953. Some of the victims were homosexual men who were killed after he'd pushed the neck of a broken bottle up their anus and left them to bleed to death.

At 5.46 pm, he was again interviewed by DI Brown. Also present were Detective Superintendent Jestico, DS Andre Baker (who recorded the interview), DC McMillan and his solicitor, John Slater. As Kelly entered the room he put his fingers in his mouth, removed Bell's ring, placed it on the desk in front of DSI Jestico and said: 'I suppose you want

that. I've had it in my mouth since I came in here.' Amidst all the furore in the past 24 hours, Kelly had kept Bell's ring in his mouth, hung on to the only tooth he had in his head and continued to eat and drink and speak without it being discovered. The reason the police hadn't found the ring was that the newly-introduced PACE Act had defined that a prisoner's mouth could only be searched as part of an intimate search, which required certain criteria to be fulfilled and had to be authorized by an officer of the rank superintendent or above. Kelly had sat in the station all day with a stolen ring in his mouth, confident that there was nothing the police could do to find it. On being informed of this, Bell reconsidered his decision and made a further statement, re-asserting his original allegation of robbery against Kelly and McManus. As for his stolen watch, that was never found and was most probably disposed of when Kelly and McManus were arrested outside the pub.

The interview concluded at 6.43 pm and the notes were then signed by both Kelly and Slater. In the course of the interview, Kelly again admitted the four murders and two other assaults in which he felt that the victims might have died. At 7.10 pm Kelly was charged with murder. When the charge was read over, he was cautioned and made no reply. On Saturday, 6 August 1983, he appeared at South Western Magistrates Court and was remanded in custody until Monday, 15 August 1983.

Due to his admissions, CID officers met and opened a major investigation into Kelly's criminal past in which I had a crucial role. At the time I was 28-years-old, newly married with a baby on the way and had completed eight years police service and worked as a uniformed constable. I knew working on the Kelly enquiry was a great opportunity to showcase my skills and would give me something to talk about at my anticipated CID selection panel. I threw myself into it with gusto, regularly working 16-hour shifts and longer. My roles included arranging Kelly's weekly remands and collecting, collating and updating all the case papers for court.

First of all, I was dispatched to the offices of the local newspaper, the *South London Press* in Leigham Court Road to go through back copies of the newspaper from the coronation in 1953 to the present day in 1983 to check for details of possible crimes that could be attributed to Kelly. It took two weeks to trawl through 30 years of news to unearth reports of 'suicides' on the Northern Line. I then went to Wandsworth Prison to examine Kelly's lengthy prison file and check his periods of incarceration to see whether he was free on the dates that these 'suicides' occurred. Other officers were sent to the scenes where Kelly said he committed his crimes. However, if he wasn't attacking strangers on the London Underground, he would lure his victims to derelict and abandoned buildings. These had now been demolished and replaced with new homes and offices so that no further investigations were possible. Yet more officers were conducting research into Kelly's life history and attempting to trace all the victims and witnesses that Kelly could name.

Unsurprisingly this wasn't a great success because unless they were already dead, they were probably in prison or living a nomadic lifestyle with no fixed address. It didn't help that if Kelly did know a victim's name, it would be a nickname, which was impossible to trace on official documents. Detectives failed to find any key witnesses at all but continued to file reports back to the management team, who were trying to come to terms with what they were dealing with and deciding what to do next.

Five days after confessing to being a serial killer, and while detained in Brixton Prison, Kelly admitted two further murders to his solicitor, Slater. As a consequence, when he appeared at South Western Magistrates Court on 15 August 1983 an application was made by the police for him to be remanded back into police custody so that further enquiries could be made. This request was granted by the magistrate and Kelly was remanded in police custody for three days. During the subsequent interviews, Kelly admitted a number of further murders. In total he

confessed to 16 murders. On 19 August Kelly was again remanded in custody for another seven days. As more of his crimes emerged, it was dawning on the police and prison staff that they were dealing with a prolific serial killer.

More than three decades later, in 2016, I met some of the officers involved in arresting and detaining Kelly, McManus and Boyd. I wanted to establish what they could recall about the individuals and the events that brought them together on that fateful day. PC William Fox and his fellow arresting officer PC Gerard Beith were both coming to the end of their first year of service, having spent four months at the Metropolitan Police Training School at Hendon and three months on a street duties course before working alone or in pairs for the next five months. Fox went on to have a very successful career as a drugs squad officer and surveillance officer at New Scotland Yard, but resigned after 15 years to start his own business. He had strong memories of Kelly and McManus.

'I will never forget Kelly's eyes,' he said. 'They never stopped moving. All the time, he was looking for angles, checking the odds, looking for an opportunity. You could see that he was a player, weasel looking and devious, he was also confident and supremely arrogant. I had no doubt that he had robbed the old boy but never envisaged us being able to charge him for it, and Kelly knew it.

'McManus was clearly Kelly's lieutenant. He didn't say much and let Kelly do the talking. He did watch Kelly very closely and he followed every instruction that Kelly gave him, with a nod, a wink, or a statement that McManus quickly supported.

'Boyd was sitting on the bench in the cell when I put Kelly and McManus in the same cell, cell number three. He was bouncing up and down with his head tipping from side to side and he was singing, "Diddly dee, diddly dee" constantly. I remember Kelly looking at Boyd disdainfully

as he entered the cell. He was clearly not impressed with the choice of cellmate.'

PC Patrick Myhill was the jailer, assisting PS Christopher Lynch, the custody officer. He was even more of a rookie than Fox, having joined the Metropolitan Police in January 1983 and arriving at Clapham in June, while still on his street duties course. He was not allowed to leave the police station unless supervised. A day working as jailer was part of this training. He went on to become a detective chief inspector in the National Crime Squad and is now the director of operations at United Kingdom Anti Doping where he attempts to prevent athletes from using performance enhancing drugs.

'Chris Lynch was very new,' he recalled. 'He had joined us that week as a newly-promoted sergeant. That might actually have been his first day at Clapham. I remember him running into the cell to help Boyd and then seeing him with his shirt totally covered with Boyd's blood. Various people led Chris out of the cell four times but he just kept sneaking back to try and help Boyd. He couldn't accept that there was no more that could be done. I guess he felt bad about putting them together but there were few alternatives and no reason to think that any of them were any better.'

Fox and Myhill were both called as witnesses. For Myhill, this was the first time he'd ever been called to give evidence and while Fox had, it had been in a magistrates court, not a crown court, never mind the Old Bailey. Fortunately, their inexperience didn't matter as their evidence proved that Boyd had been murdered but not by whom and so it was not seriously challenged.

PS Lynch refused to be interviewed. I wonder if he feels some sort of misplaced guilt or responsibility for the events that occurred. He shouldn't. Everyone I spoke to had nothing but praise for his efforts to help Boyd. Unfortunately, I did not receive a reply from the former APS Susan Chessun or former PC Beith, both of whom have now retired.

The Police Response

In order to assess the police response to Kelly's multiple confessions and Boyd's murder, it is necessary to consider the nature of the Metropolitan Police at the time. It was, in essence, a disciplined service employing uneducated men, the majority of which had served in the Army, Navy or Air Force during the Second World War or in the National Service that followed. They were used to wearing a uniform and obeying orders. Male recruits were usually between 30 and 35 years of age and were required by police regulations to live either in a police section house if single or in married quarters if they had a wife. They were totally dependent on the police service and if disciplined, faced unemployment and homelessness. Thus they looked after each other and defended each other against complaints and allegations.

When I joined the Metropolitan Police in 1975, it was looking for male, white, heterosexual, Anglican men, at least 5ft 10ins tall and of a commensurate build, who did what they were told. Today, thankfully, they seek men and women of all racial and gender identities, of all sizes and creeds and people capable of independent thought. In 1975, it was also common practice to send the youngest, most innocent probationer to deal with a report of sudden death. They would then determine whether the death was suspicious and required the attendance of the detective chief superintendent to investigate. However, a retired detective chief superintendent told me recently that on a number of occasions he ruled that a death was not suspicious because he was under pressure at work, had no overtime budget or was bogged down with too many social engagements. By 1978 the rules had changed and every

scene of a sudden death had to be visited by an experienced CID officer, as well as the duty officer, to establish whether it was suspicious.

At the time of Kelly's confessions, Detective Chief Inspector (DCI) Charlie Poyser was in charge of CID at Clapham. However, as he was in failing health and had a number of other responsibilities, he delegated the investigation to his deputy, DI Ian Brown who was assisted by DS Andre Baker. With 16 allegations of murder against Kelly, there was a lot to be done and every detective at the police station was engaged in the enquiry for two weeks. Cell number three was now a crime scene that had to be preserved for senior officers to inspect and all forensic exhibits, photographs and fingerprints had to be collected. Officers then started to interview Kelly's friends and associates and investigate his employment history. I was tasked with reviewing old editions of the *South London Press* for any clues about unsolved crimes or suspicious deaths and checking through Kelly's lengthy prison file at Wandsworth Prison.

After about two weeks, things started to calm down and the decision was made to return all but one of the detectives to their usual duties. This one officer would play 'point' in the case and act as the focus for all future contact with Kelly. This would allow the officer to build up a rapport with the prisoner and perhaps get a better understanding of him. The selected officer would also take responsibility for arranging Kelly's transportation to and from the court for his weekly remands into custody. When I returned from my duties at the *South London Press*, I was pleased to hear that I had been selected for the role. Aside from conducting the interviews, which was done by DI Brown, recording and typing up the interviews, which was done by DS Baker and DC Kim Clabby and writing the 'legal aid' (the report of the facts of the case to be given to the director of public prosecutions, solicitor and barrister who would prosecute the case at court), which was also done by DI Brown, I would be responsible for the entire enquiry. At the time

I was a uniformed constable functioning as a detective constable pending a selection board in a few weeks. I would report to DCS Ray Adams, head of Lambeth CID, who I would meet with every Friday afternoon. Occasionally, I was summoned to report directly to Commander Alex Marnoch, the head of all police in Lambeth.

My first tasks were to trace the original files and exhibits from previous investigations of Kelly's crimes over the past 30 years as well as locate witnesses, many of whom had given statements at the time but had since moved on and were no longer contactable. I succeeded in tracing all the murder files through Department C2/5 (CID case papers), the murder room – the general registry at New Scotland Yard – and by poring through the National Archives in Kew. I also tracked down forensic exhibits, which consisted of clothing and personal possessions belonging to the victims, most of which were heavily bloodstained. A group of scientists wearing gowns and masks used five feet long wooden pincers to pick up the exhibits and transfer them to boxes for me to convey back to Clapham. In my ignorance, when I got back to the station, I opened all the exhibits by hand, checked them against the lists provided, examined them, relisted them in accordance with current instructions on current forms, sealed them in new bags and added them to the property tracking system. The following day I delivered all the exhibits to the Metropolitan Police forensic science laboratory, two miles from Clapham Police Station, so further analysis could be done.

My next task was to trace every witness who had made a statement during any of the original enquiries and ask them to supply a new statement even though the incidents had happened years earlier. They were also warned that they might be called to give evidence in court. Inevitably, some of the witnesses had died, some had emigrated and others could not be traced. When they were no longer available, the evidence was reviewed in order to identify new witnesses who could cover the material lost. This was

painstaking work involving visits to neighbours, checks of voters' registers and tracking through employment records.

With 16 allegations of murder to investigate there were a considerable number of people who had suffered as a result of Kelly's actions. One day I met three widows who had lost their husbands to Kelly. They each told me the same story, which shed some light on Kelly's dishonest, manipulative nature and his ability to turn the finger of blame away from himself. The three men had all left home in the morning to go to work in the City of London. Then, just after lunch, each woman received a visit at home from a local police officer, informing them that their husbands had committed suicide by jumping underneath underground trains on the Northern Line. As the women each struggled to come to terms with what had happened, the police officer went on to explain that a witness (Kelly) had told the police that he had been talking to the man in the moments before he committed suicide and that the stranger had said his wife had been unfaithful and that he just could not continue with his life.

When people fall to their deaths under trains on the London Underground it is usually difficult to establish whether it is suicide or murder. Watching a recent episode of the Channel 5 documentary series *The Tube: Going Underground* I noted that when this situation arose, a call was circulated as 'PUT' (person under train). This is a neutral term, indicating neither that the victim was pushed under the train nor that he or she committed suicide. A few seconds later, the recipient of the call said: 'We've got a jumper.' This is a clear indication that these deaths are usually considered to be suicides rather than anything more sinister and it might explain why Kelly was acquitted so often. After speaking to the three widows, I resolved to call each of the insurance companies that had refused to issue a payout following their husbands' deaths and *encourage* them to reconsider that decision as a matter of urgency. It is a matter of pride to me that each and every one of them made immediate payments to the women.

It is difficult to pinpoint what went wrong with the earlier investigations, which meant that Kelly was consistently acquitted or the jury felt unable to reach a verdict. One problem was that the British Transport Police did not keep a registry of the names of victims and suspects following any suspicious incidents and they failed to identify the frequency with which Kelly's name appeared in police files. In the Metropolitan Police all files were sent to a general registry, which used to be situated near New Scotland Yard. Details of individuals named in any report, their addresses and their vehicles were indexed, so that patterns could be established. As Kelly was often a named witness, if this had happened correctly, attention would have been drawn to Kelly after the second or third incident, rather than allowing him to function as a serial killer for 30 years.

Another reason for Kelly being acquitted so regularly was that nobody had ever managed to ascribe a motive to him. Defence barristers posed the question: 'So why would Mr Kelly want to kill Mr Smith? Members of the jury you have heard today that Mr Kelly is a man who pees in bushes. How would he know Mr Smith? You have heard today that Mr Smith is a rich and famous man who lives in a big, smart house miles away from Clapham, where Mr Kelly lives. Why would Kelly want to kill Mr Smith?' Lawyers like motives. Kelly never inherited any money from his victims or benefited in any way from their deaths. By questioning the motive, or lack of one, Kelly's barrister managed to sow a seed of doubt in the jury's mind.

With new statements to hand, it was now time for Kelly to be interviewed again. As he had already been charged with Boyd's murder, he had been remanded in custody in Brixton Prison and had to appear at South Western Magistrates Court in Battersea every seven days. This was so the magistrate could review progress of the case, hear any complaints that Kelly or his lawyers wished to make and decide whether his detention was still necessary. Most prisoners are delivered to court by a bus system run by a security company. However, due to Kelly's Category A

status, he was transferred in 'the tank', a green, bullet-proof, bomb-proof, pyramid-shaped vehicle approximately the size of a Ford Transit van, with small cells for two prisoners and room next to the cells (just) for two police officers. Additionally, due to the threat he posed to other prisoners, under no circumstances should Kelly be detained in a cell with anyone else.

Kelly would get quite excited about his day out when, every Thursday morning, he would be removed from his cell and taken at speed up Lavender Hill with blue lights flashing and two-tone horns in order to avoid any ambush or potential prisoner escape. During the journey we were handcuffed together and despite the fact I was one of the men intent on securing his conviction and imprisonment, Kelly was always polite, obeying instructions and saying 'Yes, guv', and 'No, guv'. He would natter constantly. He loved looking out of the window and commenting on the outside world he had been cut off from for so long. He talked and I listened.

During one journey, Kelly couldn't stop talking about Liverpool Football Club, who were due to play in the European Cup final that evening. He'd even pestered his solicitor into bringing him a radio so he could listen to the match in his cell. I found his enthusiasm galling. I'd had a particularly gruelling week talking to relatives of his victims and I didn't see why he should enjoy a pleasant evening listening to football when he'd caused misery and pain to so many others. As the court broke for lunch and Kelly was remanded into custody yet again, his solicitor had to dash away to another court and another defendant. Realizing he'd forgotten to give Kelly the radio, he asked me to accompany him to his car so I could collect it. On the way back, I pulled the wire off the speaker, before wedging it back and giving the radio to Kelly. The following week I asked him if he'd enjoyed the game and smiled when he told me that the radio had failed to work.

The arrangements to convey Kelly to court were so elaborate and time consuming that when another prisoner

from Clapham Police Station had to be delivered from Brixton Prison to South Western Magistrates Court on the same day, it made sense to arrange both transfers at the same time. On one occasion, Kelly was handcuffed to a prisoner charged with child abuse. They spent the journey exchanging stories about their hatred of the police, who Kelly called 'the cossers', and as 'the tank' arrived at the court, both listened as I explained to the police inspector in charge, the risk each of them posed. 'This man', I said indicating to Kelly, 'is suspected of 16 murders, including one of a fellow prisoner in a cell at Clapham Police Station. Under no circumstances is he to be placed in a cell with another prisoner.' I then turned to the other prisoner. 'This man', I explained 'is a child abuser. He has seriously injured and blinded his two young daughters and is a Category A prisoner. It is feared that other prisoners are intent on hurting or even killing him and under no circumstances is he to be detained in the same cell as any other prisoner as he might be killed or kill the other prisoner when attacked.'

On the way back to Brixton Prison their attitude to each other had changed. Kelly enjoyed the notoriety that surrounded him and his court appearances; he liked the fact he was too *dangerous* to share a cell with another prisoner and that two police officers had to be with him at all times. However, here he had met his match and neither man wanted to be seen as more evil than the other. The child abuser was much bigger than the slight Kelly and as they got to the top of the stairs leading to the van, the child abuser pushed Kelly back down. Obviously, as the two were handcuffed together, he was pulled down as well and fell on top of him. Once back in the van, they sat next to each other, face-to-face, eye-to-eye, neither blinking as they turned the handcuffs against each other in order to inflict pain. And then the attacks started:

'Child abuser.'

'Murdering scum.'

'The people I killed deserved it. I don't pick on innocent children.'

'You murdering bastard! You've killed 16 people. You scum!'

'I may have killed 16 people, but I've never hurt a little girl. Especially my own daughter. You scum.'

'I've never killed anybody.'

'You're not man enough to pick on men. You pick on little children. I'll happily make you number 17 on my list any time you like.'

'Not if I don't turn my back you won't.'

Suddenly they both went berserk and attacked each other as best they could while handcuffed to each other.

It was at one of these weekly appearances at South Western Magistrates Court that the defence solicitor stated that Kelly was to be charged with a murder that had taken place many years before. At the time, Kelly had been the chief suspect and had been bailed to return to the police station, pending further enquiries but the case had then collapsed. Checks at the Criminal Records Office confirmed this was true. A group of six vagrants, including Kelly, had been drinking heavily together when one man died after falling under an underground train. The four witnesses had all pointed the finger of blame at Kelly who was arrested. Due to the intoxication of the witnesses, it was felt unsafe to charge Kelly until further enquiries had been made. He was bailed to return in a few weeks but, in this short time, all four witnesses had died. Without any witnesses, there was no prospect of a conviction and the case was dropped. Until now.

As Kelly was in full confessional mode, he admitted he'd done it. He said that before throwing the man under the train, they had engaged in a hard drinking session and he had given him orange juice laced with white spirit. A post mortem had ruled the cause of death as liver failure, rather

than injuries from the train. Officers in the present enquiry now needed to prove that it was white spirit that caused the liver failure and contacted the pathologist who had conducted the post mortem. Now a leader in his field, he was at the time inexperienced and at the start of a long and promising career. During the interview, detectives gathered the original notes to see if white spirit had been detected. The pathologist went pale. Apparently, once he recognized that he was dealing with a lifelong alcoholic, he had jumped to the conclusion that the death was a result of cirrhosis of the liver and had failed to conduct an examination of the deceased's stomach. This meant that he was unable to verify Kelly's claim that white spirit had brought an end to his life.

The officers also decided to look into the deaths of the four witnesses to see whether they could be linked to Kelly. Serial killers tend to focus on minorities such as prostitutes or the homeless. These people are often detached from society and it can be easier to dispose of them without anyone noticing, or caring. Any witnesses are invariably other members of the same community and they can easily be got rid of as well. Unsurprisingly, with no addresses, employers or family members to contact, officers could find no leads and no charges were brought.

Around four months after Kelly had murdered Boyd in the cells at Clapham Police Station, it was felt that all the necessary statements had been taken, exhibits had been examined, the reports had been filed and we were ready for the trial. The defence counsel elected for an 'old-style' committal, in which all the prosecution witnesses would be heard in full, in front of a reviewing magistrate, who would then decide whether there was a *prima facie* case that qualified to be sent to the crown court for trial before a judge and jury. The defence did not have to produce any witnesses and could just snipe at the prosecution witnesses and undermine them. It is a general principle of English law that it is the responsibility of the person or body making an allegation to prove it beyond reasonable doubt.

The committal was held at what was then Lambeth Magistrates Court on Renfrew Road in Kennington and as the date neared everything was checked, rechecked and checked again. Nobody wanted to be responsible for making a mistake that allowed a serial killer to be released back to the public. An officer was dispatched to check that the key witness, McManus could be located. Worried that Kelly would murder him if he got the chance, McManus had been assured of police protection and been given the pager number of various officers and told to call any time day or night. Due to having no fixed address and his tendency to disappear, he'd also been asked to sign on at Clapham Station every day so the police were aware of his whereabouts. It was agreed that if he did so, a £1 note would be left for him daily in the bail book. And so it was that every morning at 9.00 am, McManus would walk into Clapham Police Station and ask the young PC on the front counter to sign on in the bail book, quoting reference 41/1A. The PC would find a £1 note stapled to the sheet alongside a note explaining the circumstances. McManus would take the note, tip his hat to the officer, wish him or her a good day and gleefully leave the station to head for the nearest off-licence for breakfast. It worked extremely well and on occasions, when the detectives needed to speak to McManus, they were waiting to present him personally with his £1 note.

Early in the morning of the day of the committal, the witnesses arrived and were ticked off on a list before being provided with a cup of tea and a biscuit. Then the news that everybody had been dreading arrived: McManus, the man sharing the cell with Kelly when he murdered his other cellmate, was not where he was supposed to be and could not be found. Officers were sent off to search his regular haunts including the commons and parks of south London. Enquiries were made with the local police stations and magistrates courts to ensure that he had not been arrested. Local hospitals were contacted to see that he had not been involved in an accident. Then a call was

received announcing that McManus had turned up at the front counter at Clapham Police Station demanding his £1 signing-on fee and was currently in the police van being delivered to the court.

McManus was in a terrible state. He was flat out drunk and totally incoherent, covered in dirt, urine and vomit. In the normal course of events it was likely to take six hours for him to sober up and more if he was to be considered a reliable witness. Unable to stand, he was laid down in the very small court lobby that provided the only means of access and egress to the building. A few moments later all the major players arrived at court and each of them, regardless of rank, was required to step over the prosecution's star witness. The defence team started to make plans for the afternoon, confident that their client would be acquitted and on his way home by lunchtime.

The prosecuting counsel went into blind panic. McManus was the first witness and was due to give evidence in 20 minutes. Swift action was required so I took the brief off the prosecuting counsel and turned it upside down so that his first witness was now his last and his last witness was now his first. Detectives were then called upon to help McManus to the bathroom where he was placed alternately in scalding hot and freezing cold baths, in order to sober up. This process was aided by the purchase of a pot of strong black coffee, which was then poured down McManus's throat. One detective went to the local chemist to buy soap, shampoo, a razor, comb, toothpaste and toothbrush and another visited the local Oxfam shop in order to pick up a suit, shirt, tie and shoes. When McManus had shaved and washed, he was rewarded with a greasy breakfast and started to feel better. The officer returned with a grey pinstripe suit that fitted McManus rather well, but he had failed to find a suitable shirt, tie or pair of shoes. After a hunt, a detective found a white police shirt left by a police officer, which McManus wore open at the neck, and his own shoes were washed under the tap, dried and put back on his feet.

By lunchtime, McManus was upright, relatively steady on his feet and was paraded in front of DI Brown to see if he was ready to go in to court. Unhappy to see him without a tie, Brown went out to his car and picked up his old, red Metropolitan Police Flying Squad tie, with its swooping golden eagle emblem, and gave it to McManus. Realizing McManus was unable to put it on himself, DI Brown did the honours. At 2.00 pm, and looking as respectable as he was ever going to get, the court returned from lunch to hear his testimony.

McManus was put into position just behind the door leading to the court. Evidently nervous, detectives rubbed his shoulders and fed him words of encouragement until the door swung open and an usher called his name. Staring into the sea of faces, he took hold of the rail, steadied himself and then tripped on the step up to the courtroom. Every eye in the court was upon him. Expectation was high for both the prosecution and the defence.

McManus had probably made more appearances in court than most QCs having faced charges of begging, shoplifting and being drunk and disorderly. Maybe this, coupled with the fact he was still half cut, gave him a confidence that allowed him to give the performance of his life. He convinced the magistrate, without a shadow of a doubt, that he had seen what he said he had seen and that Kelly had killed William Boyd. Kelly was swiftly dispatched and duly committed to the Old Bailey to stand trial on all charges. The prosecution had lived to fight another day. Now for the real deal: five murder trials at the Old Bailey. Surely Kelly would now be exposed as one of Britain's most prolific serial killers.

The Trial

*'Courts are bewildering places, but none more so
than this one. Everything about it is designed to be
intimidating, from the stone walls that rise like a fortress to
the grand marble halls within, and their scowling murals
of Moses and King Alfred. The Central Criminal Court,
as it is properly called, was built in 1907 when the law
was synonymous with empire. "Right lives by law," says a
motto carved into the wall, "and law subsists by power".'*

Cole Moreton,
The Independent on Sunday,
25 February 2007

The Old Bailey, or Central Criminal Court to give it its
proper name, is the senior criminal court in England and
Wales. It is situated about 200 metres north west of St
Paul's Cathedral, at the junction of Old Bailey and Newgate
Street, and along the 'bailey' (fortified wall) separating the
City of London and the City of Westminster. The original
medieval court was first mentioned in 1585 and grew in
size thanks to a gift from Sir Richard (Dick) Whittington.
It was destroyed in the Great Fire of London in 1666 and
rebuilt in 1674. It was rebuilt again in 1774 and a second
courtroom was added in 1824.

In the 19th century, the Old Bailey was a small court
adjacent to Newgate Gaol. Until May 1868, hangings
were a public spectacle and the condemned would be led
along Dead Man's Walk between the prison and the court.
Riotous crowds would gather and pelt the accused with
rotten fruit and vegetables and stones. In 1807, 28 people
were crushed to death after a pie-seller's stall overturned. A

secret tunnel was subsequently created between the prison and St Sepulchre's church opposite, to allow the chaplain to minister to the condemned person without having to force his way through the crowds.

The present building dates from 1902 when Newgate Gaol was demolished. It deals with the most serious criminal cases from London and, in exceptional cases, from other parts of England and Wales. Trials at the Old Bailey's 18 courts are open to the public, albeit subject to stringent security procedures. Above the main entrance is the inscription: 'Defend the Children of the Poor & Punish the Wrongdoer'. The Yorkshire Ripper Peter Sutcliffe, serial killers Dennis Nilsen and Dr Crippen and Ruth Ellis, the last British woman to be hanged, were all tried and convicted at the Old Bailey. Tory grandees Jeffrey Archer and Jonathan Aitken have also been in the dock here.

By the time Kelly appeared before the Old Bailey in April 1984, he faced five charges of murder. Although the prosecution took the view that he had committed 16 murders, it was felt unnecessary to charge for all of these. This was because one conviction would be enough to earn him a sentence of life imprisonment, which was the greatest sentence that the law permitted for any murder. A decision was taken by the director of public prosecutions (DPP) to seek to convict Kelly of two murders. The remaining charges, including the attempted murder of McMurray, would then be left on file, where they could be resurrected if he ever appealed successfully against either of the convictions. By doing this, it prevents prisoners who feel they may be able to secure an appeal on one charge from doing so, as there will always be a second conviction to justify a term of life imprisonment.

Even though Kelly had confessed to so many murders, the prosecution knew it would not be easy to secure a conviction for many of his historical crimes. It had been 31 years since he pushed his best friend, Christy Smith, under a tube train at Stockwell Station during the Queen's coronation in 1953. Since then many witnesses had died,

were seriously ill, had moved away, had faded memories or they failed to see the purpose in pursuing the matter. The prosecution knew they would have a battle to find evidence for this incident three decades on.

Arriving at the Old Bailey for the first day of the trial, I was informed that the case of R v Kelly had been listed for the high-security court number two. R is an abbreviation for *Regina*, the Latin word for Queen, in whose name all criminal prosecutions are conducted. I calculated that it would take around a month to complete five trials for murder, most of which were pretty straightforward. That would mean one week for each trial with a couple of days less in one case. Having reported my presence to the police room, I went to Court Two to introduce myself to the court clerk, the stenographer and the usher, with whom I would be working for the next month or so. I would be sitting behind the prosecuting barrister and I surveyed where the judge, barristers, jury, probation officers, social workers and press would be sitting and where Kelly would be standing in the dock.

The trial started with everybody introducing him or herself to the court. Next the charges were put to Kelly, who despite having confessed to the crimes fully and without hesitation before, pleaded not guilty to all charges. When the pleas had been recorded, the defence counsel rose and asked for each of the counts on the indictment to be heard separately as he felt his client might not get a fair trial if the jury heard just how many murders he'd been accused of. This was entirely predictable and readily acceded to by the judge. The court then proceeded to select a jury. The clerk of the court called out names and some were rejected and some were questioned until the panel was filled. When the prosecutor objects to a potential juror, he or she proclaims: 'Stand by for the crown'. When the defence objects to a potential juror he or she calls out: 'Objection'.

The first trial concerned Kelly's final murder: the killing of William Boyd in Clapham Police Station the previous year. McManus was the key witness, having been in the

cell when the murder took place, and he was the first to be called. Despite his reputation for being drunk and unreliable, there was no scrabbling round to find him, as he was present and correct on the day. In fact he gave evidence so well that he was congratulated by the prosecuting counsel. A number of police witnesses were then called to give evidence. They ranged from the officers on duty at the station that day, to the senior detectives who interviewed Kelly, as well as the scenes of crime officer, the fingerprint officer, the photographer, the forensic medical examiner, the paramedic and the pathologist. The defence challenged every point and declined to accept almost anything in statement form, challenging the prosecution to produce every witness and every exhibit. No witnesses were called for the defence. Not even Kelly.

It therefore came as a shock when the jury announced that they were unable to reach a unanimous verdict. The judge told them he could accept a majority verdict in which ten out of the 12 jurors agreed. The jury returned several times to express the opinion that this would not be possible and eventually the judge accepted this view and ordered a retrial. Understandably, the result triggered considerable debate. Three men were in a locked room. One is strangled and as you cannot strangle yourself, one of the other two must be responsible. Even Kelly had admitted this to his cellmate, the alleged rapist, then to police. Nobody, not Kelly or his legal representatives, had ever accused McManus, the other man in the cell, of being guilty and McManus had never confessed to the crime. What *reasonable* doubt could there be?

The next trial started again the next day with a new jury and a new allegation of murder. Witnesses filed through the court every day and evidence was given until a few weeks later when there was another hung jury, another mistrial. The reason the defence counsel had wanted separate trials became clear. They could make the same allegations against all the witnesses in all the cases, in front of different juries and they would accept it as being justification for reasonable

doubt and acquit Kelly. There were four mistrials in a row before a jury found Kelly guilty of murdering Hector Fisher in Clapham in 1975.

This happened after it was decided to run one of the mistrials again. As one might expect in a retrial, it was largely a repetition of what had been said before. Then, suddenly and without warning, the defence counsel called evidence from Kelly that he had been in prison at the time Fisher's murder had taken place. He claimed he couldn't have done it as he had a cast-iron alibi. If true, it was irrefutable but why hadn't this come out before? The law requires that any prisoner proposing to call alibi evidence, as it is known in court, must serve formal notice on the prosecution within 14 days of the committal to the crown court. It was now over six months since Kelly's committal and he had already been through one trial for this offence and only now was he informing the prosecution that he had an alibi.

Nevertheless the judge allowed the alibi evidence to be heard. It was 11.30 am and the prosecution was given until 3.00 pm to produce evidence with which to challenge it. Urgent calls to the Home Office prison department in Tolworth Towers in Surrey, were made from the police room at the Old Bailey. After checking, the records department confirmed it held no records of Kelly's imprisonment in 1975. Suddenly, the reason for waiting until now to produce an alibi became clear. Home Office policy was to destroy all files after a specific period of time. In Kelly's case the files had been destroyed just a week or so earlier. If the defence honestly believed that Kelly had been in prison at the time of this offence then surely they would have raised the issue in the earlier trial. Clearly, this was a dishonest strategy to secure an acquittal for their client.

As the telephone conversation to the prison department became more desperate, the prosecution team was thrown a lifeline. A few years ago, a very small pilot project had been commissioned by the Home Office that looked at the feasibility of computerizing the vast amount of prison records. As luck would have it, because Kelly's

old paper file was exceptionally large, it had been one of those selected to be computerized. So, although the original file had been destroyed, the computerized file still existed. The prosecution sighed a mass sigh of relief until someone questioned whether the computerized file had met the criteria to be classified as an official record so that it could be included as evidence. Frantic enquiries at the Home Office revealed that it would meet the criteria if the computerized version was checked for accuracy not once, not twice, but three times, by increasingly senior members of the Home Office staff. The only other issue was getting an official from the Home Office to come to court to give evidence and disprove the defence team's alibi. It was now 1.00 pm.

However, in order for an official to come to court to give evidence, the Home Office police commander in charge of Department P5 had to give his or her authority. Unfortunately, the commander was off sick, his deputy was on annual leave and his assistant was on a course. There was nobody else, explained the helpful Home Office official to me on the phone. It was a small department. No one could possibly attend court without the necessary authority and the only person to outrank the commander was the home secretary, who was otherwise engaged.

At 2.00 pm I decided to leave the court and travel to Tolworth and see what could be arranged. I was satisfied that the potential release of a serial killer was sufficient emergency for me to drive my police vehicle (which I had been given access to every day throughout the trial) in excess of the speed limits and drove there with haste. I arrived at Tolworth Towers at 2.30 pm and met the Home Office official to whom I had been talking on the phone. Together we tried to seek a solution but as time did not permit this luxury I relied on my 6ft 6ins, 23-stone frame and background in weightlifting, powerlifting and caber tossing and bundled the Home Office official into the red Morris Marina. I took off down the A3 at 80 miles per hour and as I drove, I told him that he could leave the vehicle at

any time, but that I would not be slowing down for him to do so and that I did not recommended it.

We arrived at the Old Bailey on the dot of 3.00 pm but it took a few minutes to find a parking spot. I begged for assistance to have someone else park the car but it was declined. Eventually, I ran into Court Two just in time to hear the judge address the jury on why it was necessary to acquit Kelly. When, after a brief delay, I explained the situation rather breathlessly, the judge issued a warrant for the arrest of the Home Office official but suspended it for five minutes to allow the man who was still in the car to get himself into court and be ready to give evidence. This was the only excuse that the Home Office official needed and was as good as the nod from his police commander. He duly arrived, read from Kelly's computerized record and informed the judge that Kelly had not been in prison on the day of the murder and was as free as a bird to commit any crime he wished.

Having caught the defence lying so spectacularly, the judge halted the trial and summoned the defence counsel and solicitor to his chambers and informed them that he would have the charge put to Kelly again at 4.00 pm. If Kelly pleaded guilty he would be sentenced to life imprisonment. If he pleaded not guilty, the judge would then consider what further action was required, such as sending the defence team to prison or referring them to their professional bodies, thereby ending their careers and reputations. Eventually Kelly pleaded guilty to manslaughter and was sentenced to life imprisonment. For good measure he thoughtfully commended my actions, which would prevent any unnecessary allegations of kidnap and false imprisonment. The prosecution team was then faced with one conviction for murder and one conviction for manslaughter and decided that they needed to take advice on whether to continue with the mistrials or to bring the case to a conclusion. The DPP instructed them to leave the reset of the cases on file and bring the trial to a conclusion, which they did.

It was over. Finally. I had badly miscalculated when I estimated that the five trials would take around a month to complete. Instead it had taken six months, during which my normal working life had been put on hold. I'd spent every working day sitting in court behind the barrister, listening to the evidence and dealing with the witnesses. Now, after a 30-year-reign of terror, Kelly was set to pay for his crimes. But there was one small problem.

Although originally facing five charges of murder, Kelly had been sentenced to life imprisonment on each of the two charges for which he had been convicted. However, no recommendation had been made as to the tariff – the number of years – he should serve before he would be considered for parole. This was because after sentencing him to life imprisonment for murder, the judge in the first trial in which Kelly had been convicted had anticipated another four trials and thus hadn't specified any minimum time. The judge had expected Kelly to have been convicted of a few more murders in due course and planned to make a recommendation that Kelly serve a 'whole life term' after the final trial. The judge in the second trial in which Kelly had been convicted had sentenced Kelly to life imprisonment for manslaughter, but a conviction for manslaughter does not permit the judge to make any recommendation of the tariff, so none was set in that case either. The failure to set a tariff in the first conviction had been a grave oversight. However, it was only following the second conviction that the mistake became clear to the judge and the barristers on each side. The verdict of manslaughter had made it impossible for the judge to recommend a minimum sentence and it now looked as though, despite his multiple confessions and the number of victims left dead in his wake, Kelly could be out of prison in just a few years. A person sentenced to life imprisonment may become eligible for parole after just four years. Few people felt happy with the prospect of Kelly being released after such a short time when he was suspected of 16 murders.

Solutions were sought, some of which were

unprecedented. Consideration was given to whether the case could be re-opened so that the judge could set the tariff for the first conviction. Or whether he could break with protocol and announce the tariff at the end of the case for manslaughter. The prosecuting counsel even contacted the DPP for further instructions on whether he should seek to prosecute Kelly for another of the murders that had been left on file. None of these courses of action was considered appropriate and it was finally decided to leave it to the home secretary to determine the tariff.

After six months at the Old Bailey, Kelly was sent to Brixton Prison for assessment and then on to Wakefield Prison. The tariff would have to be resolved later.

Prison Life

This chapter is written almost entirely from my personal recollections of the case as files from the Criminal Records Office at New Scotland Yard, Home Office prison files and coroner's files are generally exempted from the Freedom of Information Act 2000.

By the time he was sentenced to life imprisonment at the Old Bailey in 1984, Kelly had been living the life of a vagrant for 21 years; drinking heavily every day and stealing most of the alcohol and food that he needed to live. This brought him into regular contact with the police and resulted in him being arrested and locked up so regularly that he spent more of his adult life inside a prison cell than out.

At his trial at the Old Bailey, the judge was told Kelly had embarked on his criminal career on 8 February 1953, aged 23, and that by the time of his arrest in Clapham in August 1983, he had 39 previous convictions. This included: 15 for burglary; 13 for theft; 11 for criminal damage; three for deception; three for handling an offensive weapon; three for assaulting a police officer; two for armed robbery; two for unlawful possession; one for possession of a firearm; one for forgery; one for dishonest handling; one for actual bodily harm; one for going equipped to steal; one for threatening behaviour and one for begging. He also had six convictions in his home country of the Republic of Ireland.

At the time of the arrest, Kelly had been sentenced to a total of 37 years imprisonment and had spent in excess of 11 years actually confined, including two-and-a-half years in Broadmoor, the high-security hospital for the criminally insane. It is highly probable that he spent more time locked up than this but it cannot be proven due to prison records

being neglected, lost or destroyed. In fact, when I went to see Kelly's second wife, Esther, in 1983, I mentioned that he must have lived a crime-free life between 1961 and 1964, when they had been together as he'd managed to avoid prosecution. She contradicted me, stating that he had spent almost the entire period in prison, awaiting trial on an allegation of rape, of which he was eventually acquitted. There was no record of this in his file at the criminal records office, although this is not surprising as at this time, police officers often failed to update their files due to the pressure of work they were under.

Prison was obviously no deterrent for Kelly. Only two weeks before his arrest in Clapham Police Station for murdering William Boyd, in the summer of 1983, he had been released from Wandsworth Prison, having being acquitted of attempting to murder Francis Taylor. The acquittal came despite the fact three people had witnessed him pushing Taylor under a London Underground train at Tooting Bec Station. So when the judge at the Old Bailey sentenced Kelly to life imprisonment for each of the two charges on which he was convicted – one of murder and one of manslaughter – it came neither as a surprise to Kelly nor a great problem. Many prison dramas focus on the sound of a cell door slamming shut and locking the prisoner in his cell but this must have been more familiar to Kelly than the toilet door closing behind him. It was no big deal.

Kelly would have been used to the ropes. When a newly-sentenced inmate arrives at prison for the first time, the first task for prison staff is to inform them of their earliest release date. When a prisoner is of previous good character, has been convicted of a minor traffic offence and is told that he will be released in four weeks' time, he probably feels considerable relief, confident that he can survive that long. Yet, when Kelly arrived aged 53, not in the best of health following a life of alcoholism and having being sentenced to two life imprisonments, he knew there was a fair chance that he would die before there was any chance of release.

As no tariff had been set, Kelly couldn't actually be given date by which he could expect to be free.

The second priority for prison staff is to determine the most appropriate category in which to place the prisoner. Kelly was Category A, which is given to those inmates whose escape would be extremely dangerous to the public, the police and national security. Category A prisoners are surrounded by such a high level of security that escape should be impossible. Their incarceration requires special arrangements and the prison governor must accept responsibility for knowing the inmate's whereabouts at all times. If the home secretary were to contact the prison, the governor must be able to give the location of a Category A prisoner at a moment's notice. As a Category A prisoner, Kelly must be accompanied by two prison officers at all times when outside of his cell.

Another pressing point for staff when accepting Kelly into their prison was how to deal with his unhealthy lifestyle and addictions. On arrival, he would have been offered a packet of cigarettes or tobacco and papers, and a box of matches. He would then have been taken to the healthcare centre, where a nurse or clerk would have interviewed him about his medical history, including any addiction to recreational drugs or legal highs, which are substances capable of mimicking the effects of hard drugs. It would then be decided if Kelly had a medical dependency on alcohol or drugs and if so, it would be dealt with accordingly, most probably with prescription drugs that can either manage or wean him off the habit. Kelly would have also been judged on the risk he posed to other inmates, the risk he posed to himself and how vulnerable he was to assault from others. As a serial killer responsible for numerous deaths, he would have been the subject of contempt for prisoners who considered his crime to be one of the worst and deserving of punishment. Appendix Two of this book lists Britain's alleged serial killers, some of whom have been murdered or been seriously injured whilst in prison.

Every time an officer in the Metropolitan Police transfers

a dangerous prisoner to another officer or a lawful authority, he or she has to produce a prisoner transfer risk assessment form. Sergeant Lynch, the custody officer at Clapham Police Station had learned the hard way that Kelly posed a serious risk to others when he murdered a fellow inmate in their shared cell. In the hours after the Boyd murder, Commander Alex Marnoch, who was in charge of all the police in the borough of Lambeth, issued instructions about Kelly's supervision in custody. Although prisoners normally shared cells with one another, it was obvious Kelly posed too much of a risk and would have to be incarcerated alone. No senior officer would want to take responsibility for giving Kelly another cellmate to kill and so he was placed in solitary confinement.

On 9 February 1989, when Kelly had served a little less than five years of his lengthy sentence, the youngest of his four children, Dennis, was murdered. Ironically, Dennis died in his adopted home of Clapham, the same area in which so many of his father's own victims had met their fate. His own life was extinguished over something as silly as a game of pool, just as Boyd's death came about – most probably – from his annoying habit of singing ditties in the cell he shared with Kelly. Two lives wasted. News reports of Dennis's murder imply that the 25-year-old had inherited some of his father's more reckless attributes and although it is unlikely that Kelly was aware of his death, those who did know the connection could say there was a grim predictability to the young man's ending.

Dennis was his youngest child, born to his second wife, Esther. Kelly had lost touch with Dennis when Esther had taken their two children, Karen and Dennis – along with her five children from her previous marriage to William Haggans – back to Haggans when he was released from prison having served a sentence for bigamy in 1964. Dennis had been born in Camberwell only weeks earlier on 7

January the same year. As Kelly had no more to do with his family (or his first wife or indeed his parents and siblings) Dennis would have grown up probably knowing nothing more about his father than his name. Dennis was stabbed to death in the Bank of Swans pub at 54 Clarence Avenue, Clapham and his murder was reported in the *South London Press*:

'On Thursday, 9 February 1989, Dennis Martin Kelly, a 25-year-old builder of Lessar Court, Lessar Avenue in Clapham finished work early and took the opportunity to visit the Bank of Swans Public House in Clarence Avenue, Clapham, SW4 for a beer. His wife later claimed that this was the first occasion that he had visited that pub for over a year and that although he had been something of a tearaway, he had quietened down recently and become a good father to his two children.

'In the pub, Dennis played pool with a Chinese man. A row ensued and a few minutes later a second Chinese man arrived at the pub and spoke to the first Chinese man. Dennis then used the pub telephone to call his wife and tell her that he was "involved in an argument". She explained: "He said there was a dispute over the way that he had played a shot on the pool table. He said it was turning nasty and he wanted to get out. Dennis said I should go outside and wait for him to come home. But he never arrived."'

Exactly why Dennis called his wife rather than leaving the pub to avoid the fight is unclear. A few minutes later he received a single stab wound to his heart and he was dead by the time the ambulance arrived. Witnesses stated that it had been the second Chinese man who had stabbed Kelly and that as soon as he had done so, both Chinese men ran off down Clarence Avenue. A murder squad was set up at Norbury Police Station under Detective Superintendent John Bassett. Speaking to the press the next day, Detective Superintendent Bassett described the death as a 'totally senseless killing' and said: 'The attacker has got to be local and perhaps somebody knows of a Chinese pool player in the area.'

An inquest into Dennis's death was opened on Tuesday, 14 February 1989 at Southwark Coroners Court and adjourned until 11 April 1989. On Wednesday, 15 February 1989, a 37-year-old jobless man, Chang Ma, of Fox Hall, Upper Norwood was charged with conspiracy to murder and remanded in custody for a week at South Western Magistrates Court.

Kieran Patrick Kelly died in Durham on 6 April 2001. He was 71. An inquest held on 16 October of that year gave the cause of death as chronic obstructive pulmonary disease; a lung condition common with heavy smokers. It is highly likely that, while in prison, attempts were made on his life so it's surprising that he died at a relatively old age.

He died at 55, Finchale Avenue, Brasside, Durham, which was given as his usual address. So had Kelly evaded life imprisonment and lived out his years as a free man? Not quite.

In 1993, nine years after the trial at the Old Bailey, Kelly contacted his solicitor John Slater about a second appeal (the judgment of the first appeal from a *Kiernan* Patrick Kelly about the 1975 murder of Hector Fisher is set out in full in Appendix One of this book). In the course of his enquiries Slater had seen Kelly's file and confirmed that it bore an endorsement from the home secretary at the time (Kenneth Clarke was in office until May 1993 and was succeeded by Michael Howard), stating that Kelly must never be released from prison. And he wasn't. The Finchale address is part of Durham's Category A Frankland Prison and the address is used publicly to avoid embarrassing families of those who die as inmates there. However, it is unlikely any family member knew of Kelly's death and if they did, it's doubtful anyone cared.

Victims and Consequences

It wasn't just the victims whose lives were affected by Kelly's actions. There were the wives and children of the dead, who had to get on with their lives without husbands and fathers. There were the emergency services, the hospital workers and London Underground staff, especially the tube drivers, who clocked on, expecting to work just another day, but saw things that they never expected to see, which may have haunted them forever. There were the innocent passengers who saw strangers fall to their deaths in front of their eyes, the vulnerable members of the homeless community who feared for their lives as it emerged they had a maniac amongst their throng and the jurors who had to sit through so many gruesome details. And of course there were the police and the prison service, which spent years dealing with a repeat offender who seemed to show no remorse and no intention of ever living within the law. Even I wasn't immune to the horror of hearing Kelly's stories: they left a lasting imprint on my mind.

In order to understand the wide-reaching effects of Kelly's crimes, it is necessary to understand what he did and how he did it. Most serial killers select one section of society that they dislike, such as prostitutes or homosexuals, and attack them. However, Kelly appeared to have a number of motives as he targeted more than one group. Not only did he attack within his homeless community, he also assaulted gay men and he selected victims at random when he patrolled the platforms of the London Underground. He was a predator who killed without thinking through the consequences and whose eyes were constantly seeking out potential victims. He even resembled a hawk or an owl,

with staring eyes, a massive beaky nose and a head that appeared to rotate 360 degrees.

Kelly committed four types of murders. He killed men who made sexual advances towards him (no doubt at his invitation) by getting them to undress and then pushing the neck of a broken wine bottle up their anus, causing serious bleeding, from which the victim usually died. Kelly hated the fact he was himself homosexual, considering it to be disgusting behaviour and a dreadful sin. By killing other gay men, he was able to express his hatred and maybe this helped absolve him of his own sexual inclinations. I spoke to a number of men who claimed to have had a brief sexual relationship with Kelly. All told the same story of rejection and denial shortly after his needs had been gratified. Kelly also told me the following:

'I have always accepted that homosexuality is a sin. I have struggled with it since puberty and I was always able to resist with the security of a family around me but when that fell apart, I just couldn't handle it any more. That's why I became violent when I was propositioned by homosexuals. I feel these urges. I know that they're wrong but I can't always suppress them.'

It is interesting that once he had lost the security of his family, he made no attempt to get it back and never gave a second thought to any of his victims' families. Again, was he punishing others for his own suffering just as he punished them for his own disgust?

He always abandoned the men where they fell and never made any effort to conceal them. Accordingly, their naked and heavily bloodstained bodies were left where witnesses could find them, and in a condition that would have seriously troubled the people who had the misfortune to do so. Many of these men would have been closet homosexuals and the manner in which they died would have heaped extra pain and misery on their family and friends.

He murdered people by feeding them a cocktail of surgical spirit or white spirit mixed into orange juice. Kelly enjoyed being the provider for his fellow vagrants as it made

him feel popular. He called himself the 'laird of Clapham Common' and relished his own importance. He was happy to steal from local shopkeepers and by intimidating them into not contacting the police, he retained a certain status among the community. Even though some were aware of his violent behaviour, they were reluctant to 'grass him up' as he was useful to them. He had a ready supply of alcohol and a willing group of men who were keen to share it with him. Some of these became his victims. Some were too drunk to compute what Kelly was doing and others didn't care or, aware of Kelly's penchant for violence, were too scared to warn the victim. Even though he claimed to sleep with 'one eye open' for fear of revenge, he had many in his thrall and his control over people helped conceal his crimes.

He pushed people under trains, causing a very nasty mess, in front of members of the public, including children. The train drivers who inadvertently killed Kelly's victims never forgot the experience. It is unusual for a driver involved in an incident in which a train strikes a passenger, to return to work and most seek an alternative career as soon as their counselling has finished. Emergency service personnel who had to tidy up after the incidents were also deeply affected. On the Channel 5 programme, *The Tube: Going Underground*, Superintendent Andy Morgan of the British Transport Police explained what it is like to deal with a PUT (person under train):

'It's never pleasant. No matter how many times you deal with it or how professional you are, it always leaves its mark. Because at the end of the day, it's someone's life and it's extremely precious and that does take its toll on all of the staff and many people won't give us time to grieve or to suffer, or to have any after effects, but we're human beings and so it does happen.'

When I arranged a reunion of the police officers on duty at Clapham Police Station at the time that Kelly killed Boyd in the cell, I contacted the custody officer Christopher Lynch several times and arranged the meeting. Although

he promised to attend, he never did and he didn't call to explain his absence. Being the person who sanctioned putting Kelly, a violent serial killer, in the same cell as a vulnerable man is something he would have had to live with for the rest of his life and no doubt the incident still preyed on him.

Kelly stabbed or beat to death other vagrants if they upset him. He planned the scenes of these crimes so they took place in quiet locations such as abandoned buildings or churchyards to avoid being noticed. However he never attempted to hide their bodies and they were usually discovered quickly, sometimes by dog walkers or even children out playing. Kelly never had any thought for the damage his crimes caused others.

Over the course of our time together, I asked Kelly why he did what he did. He told me he had killed 12 times but none of our conversations were recorded because he would blurt it out in the back of a security van or when we were handcuffed together while he went to the toilet. He always responded by going back to the day of the coronation and the day he killed his best friend, Christy Smith. He'd murdered Smith because he thought his secret – that he was a homosexual – was out and it was easier to kill him than live in fear of him telling his family and friends. Kelly admitted that he had been terrified by what he had done but it had got rid of his problem. So if he enjoyed a bit of clandestine sex with another man, it seemed easier to get rid of him rather than risk him telling all and sundry that Nosey was a 'queer'. If there were witnesses to his murders, the simplest way to keep them quiet was to have them killed. Problem solved. And it was made so much easier because he enjoyed it: the kill made him feel good. He felt powerful in a world that offered him – a vagrant and an alcoholic – very little power. And so it continued.

A friend of mine, Greg Mack, calculated that a murder costs the government around two million pounds. There is the cost of medical treatment for the victim before he or she succumbs to their injuries; then the assailant may

also be hurt and may require help. When the victim dies, police will be required to attend the scene with a number of specialists, such as forensic medical examiners (also known as police surgeons) to certify life extinct and forensic pathologists to determine the cause of death and begin to collect the evidence required later at trial. Once this has been done then the body will be removed to the mortuary.

The evidence gathering will continue with photographers attending the scene to take shots of everything, as well as plan drawers who prepare sketches and take relevant measurements. Forensic scientists (also known as crime scene examiners) collect exhibits and they are followed by fingerprint experts who collect evidence. Depending on the scope and nature of the enquiry, a murder squad of 20 to 30 detectives will then be selected and will attend the scene to acquaint themselves with what has happened before proceeding with their enquiries and setting up a major incident room, with all the telephones, faxes and computers that the officers require. Meanwhile, the pathologist will start the post-mortem examination. This requires almost the same amount of staff and equipment as an operation on a living casualty and therefore costs about the same. Family liaison officers will be dispatched to relatives of the victim and will make themselves available for as long as they are required. There will, in due course, be an inquest and unless the assailant admits to the murder, there will be a trial and a jury. The press will want to cover the murders and so the police will have to provide media liaison staff to manage the flow of information. Eventually, the victim will be buried or cremated.

Following the publication of my first book *The London Underground Serial Killer*, which detailed my relationship with Kelly, I was surprised by the number of people who contacted me to share their experience of possibly being caught up in his crimes. There were police officers, train drivers, and relatives of the deceased, some of whom had been previously identified, but seven of whom were previously unknown. It's fair to say that by doing what he

did, Kelly threw a grenade into their lives that exploded and left life-long damage.

By indiscriminately pushing people under London Underground trains and then running off, many people were told their husbands, fathers and brothers had committed suicide. With no reason to believe anyone else was involved, some may have genuinely believed that. Others would have made it up to shield their loved ones from the truth. And suicide can be difficult to come to terms with, especially if they thought their husband or father was happy and had no reason to end his own life. Such was the situation with Helen McIntyre who, as explained in Chapter 4, contacted me following the publication of my book. Her brother, James Walker, had won the pools just days before his alleged suicide under a London Underground train in 1979. She couldn't understand why a man who enjoyed such good fortune should want to end it all. She had begun to question herself and wonder if it were something in their relationship that had made him so unhappy. Now, more than 35 years on, she said she just wanted 'to know'. This inability to achieve closure can plague someone for the rest of his or her life.

We get a greater understanding of Kelly's attitude towards his victims by the way he hung around after pushing people under trains. He would wait for the police to arrive and then lie to them about how, prior to throwing himself to his death, the victim had engaged him in conversation and told him about his financial difficulties and that he could not stop his wife spending money. Or the victim said his wife had been unfaithful and he could no longer tolerate it. These stories, which threw the police off the scent and caused great damage to the victims' wives and children, were then repeated to the coroner at the inquest and appeared, in detail, in the press. It inflicted extra pain on grieving people but Kelly didn't care.

The Re-investigation of the Kelly Murders

In 1983, in the days after Kelly's arrest and the murder of William Boyd, the Home Office decided that no details of the investigation should be released to the press. They expressed concern that if the public learned that a man had been indiscriminately pushing people underneath London Underground trains, it may induce mass panic and stop people using the tube to get to work. Instructions were passed to DCS Adams, DI Brown and all the police officers at Clapham Police Station to not pass any details to the Metropolitan Police press bureau, whose job it was to keep the press updated on police enquiries. Police officers accept orders without question and I, for one, could see merit in their decision and that the predicted consequences could cause long-term problems. As a result, no news of the case ever reached the press.

However, in August 2014 the official Metropolitan Police file on the Kelly murders became 30-years-old and was released to the public by the National Archives at Kew under the Freedom of Information Act. As there had been no prior publicity about Kelly, the case papers, with their random statements and exhibits, shed little light on his long reign of terror, admissions of guilt, acquittals, trials, mistrials and retrial. So, I decided to use my personal knowledge of the facts of the case to explain the case in more detail.

My book, *The London Underground Serial Killer* was published on 21 April 2015. It triggered much press interest, especially from the *South London Press* whose back copies I'd trawled through years before in order to incriminate Kelly for the reported 'suicides' on the Northern Line. However,

when the story appeared in the *Daily Star Sunday*, it claimed I'd accused the police of covering up the murders. Yet at no stage did I suspect or accuse anybody of covering up the Kelly investigation. When, during our interview, the journalist asked me, perfectly reasonably, why she had not previously heard about the case, I told her about the Home Office instruction not to discuss it with the press. So I was rather surprised when I read the headline about a cover up although I can, of course, see how it came about.

Within minutes of the *Daily Star Sunday* coming out, the story was picked up by the world's media and for the next seven days I received 300 telephone calls and 300 emails a day. I travelled to London every day for the next month and gave 120 interviews to the print press, 12 to the television and 12 to the radio. In every one, I made strenuous attempts to correct the claim of any police cover up. I also attempted to put right the oft-repeated error that Kelly's name was *Kiernan* not Kieran. This came about due to a spelling mistake made by a computer operator at the National Archives who had indexed the case papers wrongly. I explained that I had personally dealt with Kelly for two years, that I had written almost every piece of paper in the Kelly file and that his name had always been Kieran and not Kiernan. Nevertheless, much of the press, including *the Huffington Post* below, referred to him as Kiernan.

At the end of the week, the media started pursuing the Commissioner of the Metropolitan Police, Sir Bernard Hogan-Howe and the Chief Constable of the British Transport Police (BTP), Paul Crowther, for an explanation of the so-called cover up. It should come as no great surprise that these two officers had no knowledge of an investigation that had started with the first murder in 1953, before either of them had been born. They control large and diverse organizations and they cannot be expected to know about all historical cases. It wasn't until the year 2000 that the BTP was even authorized to conduct murder enquiries. Before that they were passed to the local police force, which in Kelly's case was the Metropolitan Police.

Understandably, the two officers struggled to respond to the media enquiries and both announced that they 'want to speak to Platt.' Here is the report from *the Huffington Post*:

London Underground Serial Killer Claims Are Credible Says Met Police Chief Bernard Hogan-Howe

The Huffington Post UK By Sara C Nelson
Posted: 29/07/2015 12:13 BST Updated:29/07/2015 13:59 BST.

Allegations that a serial killer operated on the London Underground during the 1970s have been described as "quite convincing" by Britain's most high profile police officer.

Former Scotland Yard detective Geoff Platt claims drifter Kiernan *[sic]* Kelly murdered 16 people by pushing them to their deaths from train platforms.

Platt also says the police deliberately "hushed up" the killings for fear of causing panic on the capital's transport network.

Responding to the claims, Met Police chief Sir Bernard Hogan-Howe told the BBC: "The detail of it sounded quite convincing, I'm not sure why no action was taken at the time."

Earlier in the week, Platt told Huffington Post UK: "The Home Office decided this was not a case they wanted broadcasted.

"They felt that if it was broadcast, workers wouldn't go to work on the Northern Line, it was a Home Office policy decision: Don't talk to the press and don't encourage the story."

Met Police chief Sir Bernard Hogan-Howe has described the claims as 'quite convincing'

But Hogan-Howe said: "That's an odd reason, I find that not very persuasive if I'm honest... I can't say I don't believe it but I'd take some persuading about that as a reason.

"We have said that we'll contact him and let's see if we can get to the bottom of what he's said."

Platt says Kelly confessed to the killings in the early 80s while he was being interviewed for the murder of his prison cellmate. Platt, 60, recalls interrogating Kelly in his new book, *The London Underground Serial Killer.*

Platt alleges Scotland Yard covered up the matter to avoid spreading public panic.

The BBC confirmed it had seen court papers from 1983 in which Kelly told police: "I'm your man for this one but now I've started, I want to tell you about some more I've done in the past."

According to Platt, Kelly was investigated for 16 murders in total and acquitted of 8.

Having been charged with three murders unrelated to the Tube deaths (that of his prison cellmate and two vagrants), it was also deemed to be not in the financial public interest to launch further proceedings against Kelly, Platt says.

Kelly was acquitted of attempted murder in 1982 for pushing a man onto the tracks at Kensington Station. The BBC says the lawyer representing him believes Kelly – who is now thought to be dead – was a fantasist.

A spokesman for the Home Office said: "Any evidence to suggest a crime has been committed is a matter for the police."

A BTP spokesman said: "We are aware of the claims included in this book but given the passage of time since they are alleged to have been committed these would prove difficult to substantiate without further evidence.

"We would invite Mr Platt to submit any information he has on these matters to us."

On the same day, Crowther went on TV to say that 'I want to speak to Platt.' As soon as I saw this, I contacted the BTP, supplied them with my contact details and assured them of my full and unconditional support. Two days later, when challenged on the case again, Hogan-Howe revised his opinion from 'quite convincing' to 'entirely credible' and repeated his request on late night TV that 'I want to speak to Platt.' I contacted the Metropolitan Police press

bureau at New Scotland Yard as soon as I saw this at 11.00 pm, supplied them with my contact details and assured them of my full and unconditional support.

As a result of my calls on Friday, 31 July 2015 arrangements were made for me to travel to the BTP headquarters in Camden, north London, to tell them what I knew of the case. After a four-hour tape-recorded interview, I left the room to be met with 25 detectives from the major incident team waving copies of my book. The Force had given them each a book and instructed them to read it three times in order to acquaint themselves with the facts of the case. I had known and worked with several of these people for many years and it amused me to have them asking me to dedicate my book to them. I then met with Detective Superintendent Gary Richardson (Queen's Police Medal), the head of the BTP's major incident team, who had been tasked with re-investigating Kelly's crimes. As we finished he asked me to act as a consultant to the enquiry and to hold myself in readiness for further visits.

As I left the office, I could not help but wonder how much a major incident team of 24 detectives, from all ranks of seniority, working on an enquiry for 12 months would cost and what it hoped to achieve. Kelly had served 18 years in prison between his arrest in 1983 and his death in 2001 and by this time, he'd been dead for 14 years. It did look as if the commissioner and chief constable had been ambushed by the press and reacted instinctively to protect their reputation, without calculating the cost to the taxpayers of their decision. At a time when chief officers are explaining that they can only afford to investigate around one per cent of fraud and that many victims of burglary and robbery should not expect a visit from the police, it seemed ridiculous. The murders had been committed up to 62 years earlier and had been investigated in 1983. The only difference now was that most of the witnesses from 1953 were now dead, as was the suspect.

Criminal cases usually deteriorate over time. Witnesses die, fall sick, and move on. Some forget what they saw

or heard. Few new witnesses appear out of nowhere. Few suddenly remember new facts that had slipped their memory. The Metropolitan Police had investigated 24 of Kelly's suspected murders between 1953 and 1983. Reports had been submitted to the director of public prosecutions (DPP) at the end of each enquiry, when the evidence was fresh and at its strongest. On each occasion a detective superintendent or above had certified that the evidence in the case was sufficient enough to generate a 51 per cent chance of conviction. A number of DPPs had staked their reputations by authorizing that Kelly be charged with a total of 13 murders. No enquiry 62 years later could undermine this decision. Equally puzzling was that, following the publication of the book, seven people who felt that they or their relatives may have been pushed under trains on the Northern Line by Kelly, got in touch with me. Yet the BTP saw no need to investigate these more recent and previously unreported crimes.

On Monday, 19 February 2016 I was again invited to the headquarters of the BTP in Camden to meet the major incident team for a two-hour tape-recorded interview. The officers from there told me that they had discovered enough case papers on Kelly to build a tower, nine feet high. They also told me they had been surprised when, during our first interview, I told them that I had conducted pretty much the entire investigation alone. However, they admitted the case papers had confirmed this because my name was just about the only one mentioned in the file. This was because I had taken all the statements and produced all the exhibits. The officers told me they had been impressed by the quality of the investigation and that they were satisfied that Kelly had been very active between 1953 and 1983. They said it was clear that he had killed a large number of people, by pushing broken wine bottles up their anuses, by feeding them orange juice laced with white spirit and by stabbing, beating and so on. However, they could find no trace of any record of Kelly pushing anybody under London Underground trains. They

asked me whether I could be mistaken, or if I could have exaggerated. I was seriously taken aback by their questions.

Having been personally involved in the investigation and having spoken to Kelly at length about his crimes, I was entirely confident of the facts. I recognized that this aspect of the case was always the most sensitive and the part that the Home Office and senior police officers had always sought to deny, despite strong evidence to the contrary. I started by pointing out that no 62-year-old civil service file was entirely complete and that there must be a substantial number of pages missing. I pointed out that I had detailed very carefully the structure of my own thorough investigation in 1983. I explained that I had started by visiting the offices of the *South London Press*, where I had read every single newspaper published between 1953 and 1983 and noted all the 'suicides' on the tube. I had then visited Wandsworth Prison and checked the dates of Kelly's incarceration to see whether he had been free the same time the 'suicides' occurred. The best way for anybody to prove that I was lying or exaggerating would be to send an officer to the same places to undertake the same enquiries. The BTP had failed to do this and told me that they had no plans to do it in the future.

I explained that I had spent a great deal of time alone with Kelly discussing his crimes. He had admitted 12 murders to me, many of which happened by pushing people under tube trains. Nobody else had been present and these discussions had not been recorded, having invariably been initiated by Kelly at the most inconvenient times, such as when we were travelling to and from court in the back of high-security prison vans or handcuffed together while he went to the toilet. I was asked to whom I had reported Kelly's admissions and I told the officers that I had always reported to DCS Adams directly. They asked me why I had not reported to DI Brown and I explained that I just did what I was told. The detectives told me that they had not yet spoken to DCS Adams and had no plans to do so. It later occurred to me that DCS Adams had been in charge of the Stephen

Lawrence case (Lawrence was a black teenager who was murdered in London in 1993 in a racially-motivated attack and police were criticized for flaws in the investigation). The allegations and subsequent internal investigations caused by the Lawrence case had probably caused relations between the police service and DCS Adams to break down irreparably, so that contact between them was impossible. This might be why they were trying to push the fact that I should have reported to DI Brown and not DCS Adams.

With my confidence boosted, I told them that Kelly had admitted pushing 'Jock Gordon' underneath an underground train and that when I tracked 'Jock Gordon' down, he confirmed that it had happened and that he laid down and let the train go over him. He later attended an identification parade at Cedars Lodge in Clapham and identified Kelly as the man who pushed him under the train. The detectives grudgingly admitted this. I then pointed out that Kelly had gone on trial for pushing Francis Taylor underneath a London Underground train at Tooting Bec Station. The detectives had to admit this grudgingly too. I was annoyed that two detectives who had clearly known of these cases should have tried to accuse me, a former colleague, of lying or exaggerating my claims about Kelly. The two detectives then used one final attempt to dispute my story. They pointed out two errors in my first book – that I had named Jock Gordon as Gordon McLintock when his name was Gordon McMurray and that I had given two different versions of what Kelly did after he murdered his best friend, Christy Smith.

I am happy to admit both of these errors. I spoke to Kelly nearly every day for two years. He was a heavy drinker who frequently altered minor details either because he had lost his train of thought or more often than not, to confuse me. He may have given two versions of his actions after the Smith murder so I questioned him repeatedly until I could ascertain which version was true. Police are used to doing this. Not every suspect presents all the details of a crime accurately and without alteration

at a later date. Kelly constantly varied his date of birth from 16 to 17 March 1930, simply to confuse police.

The two detectives also pointed out a comment in DI Brown's report to the DPP in 1983 that Kelly appeared to be admitting to crimes that he was not guilty of, in order to confuse investigating officers and juries and possibly persuade them that he was such a fantasist, he must be totally innocent of all the crimes. Again, this is not unheard of in criminal circles. Kelly may have admitted to crimes that he didn't do but he was also convicted of murder and manslaughter and there was a lot of evidence pointing to many more. If he hadn't got a black mark against his name this might be more plausible but he was a life-long criminal and convicted killer.

Detective Superintendent Richardson plans to complete the re-investigation into the Kelly case in the near future so that Chief Constable Crowther and possibly the Metropolitan Police Commissioner, Sir Bernard Hogan-Howe, may make full public statements to the media on the case. The completion of the current BTP investigation will mean that the Kelly case will have continued longer than any other investigation into a serial killer, having been investigated on a case-by-case basis as they occurred between 1953 and 1983, re-investigated universally by me in 1983 and again by Detective Superintendent Richardson 15 years after Kelly's death. I have been involved with this case for more than half my life but the enquiries are ongoing and I will continue to report the updates.

What Can We Learn From Kelly?

Kieran Patrick Kelly is the first identified Irish serial killer. In the UK there have been 62 alleged serial killers and in the USA there have been 224. But what exactly is a serial killer and how does Kelly fit into our understanding of one? Kelly's reign of terror lasted an incredible 30 years. Can the facts from his case and his constant acquittals help prevent similar cases in the future? If serial killers are at large in the future, can what we learned from Kelly's case aid in their investigation?

The term, *serienmörder* (serial killer) was first used in Germany in 1931 in reference to Peter Kürten. Known as the 'vampire of Düsseldorf', he murdered nine people, attempted to murder at least seven more and drank the blood of some of his victims. Following his arrest, he was interviewed and admitted to two motives: firstly to 'strike back at oppressive society' and secondly for sexual pleasure. Following his execution, scientists attempted to examine irregularities in his brain to see if it could explain the behaviour of a serial killer. In the intervening years a great deal of work has been done to investigate serial killers, their crimes, their motives and the ways in which they may be identified. Unfortunately, despite all these efforts the experts cannot even get started, let alone come to a conclusion, and have been unable to even define what they mean by the term serial killer.

The Federal Bureau of Investigation (FBI) in the United States of America brings all the best detectives, psychiatrists, psychologists, criminologists and sociologists together for a week-long conference every year, in an attempt to understand what it is exactly that they are dealing with. For the last few years, recognizing that there is an urgent need

to define the term precisely in order to make progress, the conference has been specifically targeted at that one question. Yet still no progress has been made on agreeing a definition. As FBI director Robert S Mueller III explains:

'Every day, law enforcement officers...are called to respond to murders. Each homicide case is tragic, but there are few cases more heartrending and more difficult to understand than serial murder. For years, law enforcement investigators, academics, mental health experts, and the media have studied serial murder....'

A vast amount of research has been conducted on serial killings and serial killers, but little of it has any practical value to an overworked detective investigating a series of murders that have clearly been committed by the same person, while attempting to prevent further deaths and identify and trace the person responsible.

So what makes Kelly a serial killer? Although no agreement has been reached on the actual definition of the term, the following issues help contribute towards our understanding of what singles out a serial killer from another murderer. Firstly, it's the number of murders. Clearly, a serial killer needs to be responsible for more than one murder, but the experts are undecided on whether they need to kill two or 10 or any number in-between. Most settle on five murders. Whatever the number, Kelly qualifies easily having confessed to or been accused of 31 murders.

Secondly, evidence of murder must be taken into consideration. A wide range of evidence may be available for consideration when determining how many murders a suspected serial killer has committed. This ranges from an unsupported allegation made by a third person, the statement of a witness, a personal admission, a police confession, the result of a police investigation, a charge being preferred, the determination of a government law officer reviewing the evidence and a formal conviction by a court of law. These types of evidence may be considered of generally increasing value, although many, if not most,

police officers would place more weight on the opinion of a government law officer than the decision of an inexperienced jury. Kelly was convicted at the Old Bailey of one murder and one charge of manslaughter. He was charged with a total of 13 murders, on the authority of the DPP of the day, on the basis that the charges had a 51 per cent chance of resulting in a conviction and the fact that the charge was in the public interest. He admitted 16 murders to the police. Independent members of the public have accused Kelly of committing 10 murders. Aside from the fact he was convicted in court of only two killings, Kelly meets all the criteria above.

Thirdly, there has to be a cooling off period between murders. Several researchers have recommended that there should be a 'cooling off' period between each of the murders so as to distinguish between a mass murder and a serial murder. Mass murder is defined as four or more murders occurring during the same incident, typically involving a single location and with no distinctive time period between the murders. The serial killer's separation between murders makes each murder a separate event with its own individual motivation. There were always substantial periods between Kelly's murders, although admittedly, these were often enforced breaks caused by his incarceration in prison.

The fourth issue is the perpetrators. The majority of perpetrators are male, white and in their late twenties or early thirties. It has also been specified that it may only be defined as a serial killing if there is a single perpetrator. Again, Kelly meets all these criteria. He was male, white and was killing while he was in his late twenties and early thirties, although of course, he continued murdering until he was into his fifties. He always acted alone.

Number five is the motivation for the killing. Serial killers tend to select a certain group in society that he (or she but almost universally he) dislikes and then proceeds to do his (or her) best to remove this group from the face of the earth. These groups have included prostitutes, homosexuals, potential witnesses and racial groups. Kelly

appears to be unique in hating more than one faction of society. He admitted killing homosexuals who made advances towards him, by shoving broken bottles up their anuses; witnesses who had seen him kill others (many of whom were his fellow vagrants who he plied with white spirit and orange juice) and people, such as William Boyd whom he beat to death because he annoyed him. Finally, he pushed random strangers under trains, possibly because they reminded him of his first victim, Christy Smith, whom he never really came to terms with murdering. Interestingly, he treated each group as a separate entity and used specific methods to kill each one.

Six is the venue. Several agencies, including the FBI have stipulated that serial killers must change the venues of their murders. Kelly always changed the venues for his – be it derelict buildings, churchyards or different tube stations – although many were very similar in nature.

To define a serial killer, other forms of killing have to be excluded. Justified homicide, for example, which includes deaths by the military, police or intelligence services on behalf of national governments, are not caused by serial killers. Accidental and negligent death caused by reckless driving or by repeated breaches of building or transport regulations, require an awareness of the danger but no intention to kill or injure, so are not suitable for inclusion as serial killings. Spree killing, in which murders are committed in two or more locations in a short time without a cooling off period, cannot be classified as serial killing. However, cases of extended bouts of sequential killings over periods of weeks or months with no apparent cooling off period or 'return to normalcy' have caused some experts to suggest a hybrid category of spree-serial killer. Contract killing or being a hit-man means murdering repeatedly for other people's motives. A murderer for hire is not a serial killer even though they may have killed a number of people in different venues and with a cooling off period.

Prompt classification today frequently results in the swift allocation of budget and resources to bring offenders

to justice. This was proven in the case of Steve Wright, otherwise known as the 'Suffolk strangler', who murdered five prostitutes in Ipswich in 2006. His behaviour displayed the hallmarks of a serial killer and it was clear he would continue murdering women until he was caught. Suffolk Constabulary is a small police force but once it was established that a serial killer was on the loose, it was able to receive substantial financial assistance from the Home Office and substantial manpower from surrounding forces, so it had a better chance of apprehending him at the earliest opportunity. He was caught in 2006 and convicted of five murders in 2008 with the recommendation to serve a full life term.

It is incredible that Kelly was allowed to kill for 30 years. A serial killer operating on the London Underground should have been identified decades earlier. However, it's not a surprise. Large numbers of people in London find the stress of living in a busy capital city too much and suicide as an effective alternative. Suicides on the London Underground are common and the police, under considerable pressure of work, may feel that these incidents are routine and that it does not require their personal attendance. Evidence is overlooked, even when it doesn't point to a suicide. Interestingly, Kelly frequently hung around after pushing one of his victims underneath a train waiting, for some perverse reason, to speak to the investigation officer and give a cock and bull story about the victim's self-confessed reasons for ending it all. With Kelly on hand there was no need to look any deeper to establish the facts.

There was a period when Kelly was murdering a person every day that he was out of prison. In fact the efficiency of the police in catching Kelly and locking him up for numerous petty crimes, probably delayed his eventual arrest for murder. It was difficult to establish a pattern when his attacks were separated by six months imprisonment here and a few months imprisonment there. Of course if he hadn't been incarcerated for so much of his life, he would most probably have killed far more.

When I published my first book *The London Underground Serial Killer,* I was of the opinion that the police had done everything possible to bring Kelly to justice at the first opportunity and that they had done a pretty good job. I was seriously surprised by the ferocity of the police response to the stories in the press, particularly when the Metropolitan Police and the BTP organized a major incident team to review the case. I now feel that this was a result of a guilty conscience.

The Kelly case is unique in many ways. Most serial killers are identified when the police start to recognize an increase in the number of local murders as well as a pattern in the methods used or possibly a signature left by the killer. Less frequently, police find a pile of bodies or, as with Kelly, they arrest a suspect who opens up to them and admits a sequence of murders. In the course of the investigation, detectives interview the suspect. The detectives highlight facts, which tend to make the suspect look guilty and the suspect's solicitor will attempt to highlight facts, which tend to make the suspect look innocent. Usually a few of these facts are leaked to the press to improve one side's case or the other. This keeps the story fresh and in the forefront of the public consciousness. Over the subsequent weeks journalists pick at the case, speaking to neighbours or friends of the suspect or the victims. Frequently, the journalists construct a nickname – such as the 'Yorkshire ripper' or 'Suffolk strangler' – that contributes to their notoriety.

The case then makes its way through the magistrates court and the crown court to trial. At this time, the suspect is held in custody or in a prison hospital to be assessed by doctors, psychiatrists and social workers. During the trial, the press and interested members of the public, go along to listen to what is being said by witnesses, police officers and barristers for the prosecution or defence, and finally by the judge. Their words are generally reported verbatim in the media. After the trial, if the suspect has been convicted, he will go to prison. He will be assessed again to see how the

realization that a long prison term, possibly with no hope of release, has affected him. Frequently, this will mean a 'suicide watch' where the prisoner is kept under constant observation 24 hours a day seven days a week, until the authorities decide that he is no longer a threat to himself or others. Serial killers are often seen as valid targets by other prisoners. Consequently, they are frequently attacked and sometimes murdered while in prison. If the serial killer does survive, around five to 10 years after their initial imprisonment authority is granted for psychiatrists, psychologists, criminologists and sociologists to talk to the prisoner to understand their motive.

As a result of the suppression of the story, the Kelly case received no publicity at the time. Even though he was arrested for murder on eight separate occasions, a scrappy murder of a vagrant by another vagrant would have failed to gauge much media attention, so he went unnoticed. Then when the Home Office decided that news of a man pushing people to their deaths on the London Underground would cause mass hysteria, they decided the story should not be released. As it had not been publicized, nobody took any notice of the case while it was at court and nobody attempted to interview his associates or those of his victims and report their evidence. My book revealed the Kelly story to the public for the first time.

Kelly's case was unique in the fact that he lived within the close-knit vagrant community, which inhabited the parks, commons and open spaces of south London. It didn't allow its members much privacy and there were no secrets. If he decided to murder one of his fellow tramps, it tended not to go unnoticed. However, any witnesses were either intimidated into keeping quiet or they were too sozzled and too reliant on 'Nosey' to provide their alcohol for them, that they didn't say anything. Contrast this with other serial killers, who tend to live quite isolated lives and, as it's often reported, the neighbours are shocked when the nice quiet man who keeps himself to himself turns out to be a deranged murderer. Steve Wright was a taxi

driver and Peter Sutcliffe, the Yorkshire ripper, worked as a truck driver. Both operated out of sight of others and fit the profile of the 'loner' we read about so often in cases like this.

Kelly is the most investigated serial killer in history. When each murder was investigated, the DPP decided that there was a 51 per cent chance of a conviction and that a charge was in the public interest. Thus Kelly was duly charged. On every occasion, bar two, he was acquitted when the prosecution were unable to tender an explanation as to why he had killed the victim. The fact is his motive wasn't revenge or money; he just found killing people solved some of his problems and he enjoyed the power it gave him. This is confirmed by his outburst and confession to 16 murders shortly after Boyd's death in 1983. Because the murder was so recent, he had not regained his composure after the attack and was still freshly reliving the pleasure the kill had given him. Following this confession, all 16 murders were fully investigated. Then, in 2015 and 2016, following the publication of my book, all his cases were re-investigated. It is unlikely that any other serial killer in the world has been better investigated. And the enquiries are ongoing. Kelly is dead and yet his terrible legacy lives on.

So what can be done to ensure that nothing like this happens again? Very likely, as we work longer hours and put ourselves under greater pressure, there will be more serial killers. Modern life with its obsession with technology and social media can be isolating and social isolation has been identified as a common trait of murderers, not just serial killers. Hopefully, as a result of Kelly's case (taking into consideration all the missed opportunities to catch him earlier and prevent him from going on to kill more) police forces will keep a better record of the people with whom they come into contact after a major incident. Thus when one person continually witnesses suicides or murders, it would be wise to investigate whether this person is also involved. If that had happened in this case, perhaps Kelly would have been stopped before he could

become Ireland's most prolific serial killer and one of the worst murderers Britain, and specifically London, has ever seen.

COURT OF APPEAL

No 4025/C/84.

IN THE COURT OF APPEAL
CRIMINAL DIVISION

Royal Courts of Justice
Thursday, 11ᵗʰ July, 1985.

Before:

LORD JUSTICE WATKINS
MR JUSTICE BRISTOW
and
MR JUSTICE SAVILLE

REGINA
V
KIERNAN PATRICK KELLY

(Transcript of the Shorthand Notes of Marten Walsh Cherer Limited, Pemberton House, East Harding Street, London, EC4A 3AS. Telephone Number: 01 583 7635. Shorthand Writers to the Court).

Mr M. BECKMAN Q.C. appeared on behalf of the Applicant.

Mr R. AMLOT and Mr T. CASSEL appeared on behalf of the Crown.

JUDGEMENT
(As approved by Judge)

Lord Justice Watkins, "On 21st May 1984 in the Central Criminal Court before Michael Davies J. and a jury, the appellant was convicted of murder. He was sentenced to life imprisonment. He applied for an extension of time and for leave to appeal against conviction. We have granted both applications.

In 1975 there was a murder on Clapham Common. The victim was a Mr Fisher, who was a vagrant, as was the appellant at that time – gentlemen of the road, in other words. The murder took place in the night of 18th July. It was unsolved. Police interviewed a large number of people, including the appellant, with no success. So no trial of anyone took place following the murder of Mr Fisher until May of last year. The only reason why the appellant came to be tried at all was that, in circumstances which I shall outline later, he confessed to police officers that it was he, all those years ago, who had killed Mr Fisher.

The deceased was last seen on the morning of 18th July 1975 when he bought a bottle of whisky from an off licence kept by a Mr and Mrs Pearson. They told the jury that shortly before the murder must have happened the deceased had come into their off licence in Clapham in the company of an Irishman. During the course of the trial the prosecution made it clear that it was part of their case that that Irishman was the appellant. There was evidence that shortly after that night the appellant had been supplied with some replacement clothes because his own were streaked with paint. Those clothes which he took off were thrown away.

At told the jury how he had seen the deceased slumped on a bench in the morning of 19th July 1975 and of his examination of him. He found in a jacket pocket, for instance, £15, and more money in his trousers, making a total of about £30. As for the more important part of his usual function, the pathologist went on to say that in his opinion the number of injuries which had been inflicted upon the deceased had been caused by a blunt instrument such as a whisky bottle or a piece of wood. Death was

caused from wounds to the chest and neck. He did not think that a metal bar had been used in the attack, but there was some evidence that quite heavy pressure had been applied to the neck. There was no evidence that he could find to the private parts of the deceased. Near his body pieces of glass were found, some of which came from a White Horse Whisky bottle.

As I have said, the appellant was amongst those who were questioned soon after this murder and he made no admissions. In 1983 he was arrested for another matter. In separate trials he was in May 1984 convicted of robbery and sentenced to 3 years' imprisonment and in June 1984 acquitted of murder but convicted of manslaughter, for which he received another sentence of life imprisonment. It was these matters which were being investigated at the time that I have mentioned. When he was being asked questions about them he began of his own volition to speak of the Fisher case, and gradually as he proceeded to tell the story it was evident that he was confessing to the murder of Fisher. He went into some detail about it. He told the police that he had walloped his victim across the head with a metal bar and then he had stabbed him in the "bollocks" (as he put it) about three times. He went on to claim that he had hit him over the head with the handle of the knife. He had taken some money from him, but had replaced something like £15 - £18 in one of Fisher's pockets. His clothes were bloodstained and he took them to a Mr Horan. He was the man to whose evidence I was referring earlier. He was provided with replacements. At some time he had been to an off licence with Fisher.

The police were understandably somewhat surprised to hear all this. They very properly found a solicitor who came to represent the appellant. During a further interview which was attended by that solicitor the appellant repeated, more or less, the story which he had told originally to the police and in clear terms admitted to the murder. He also told of an incident when he had gone to the off licence kept by Mr and Mrs Pearson, or to another one, when he

had ordered drink. It was provided to him to take away. He found then that he was a few coppers short of the price asked. It was suggested by him that he bring the bottles back and claim the money which would be payable upon returns. Mr Pearson was later on to say that there was such an incident as that involving a man, so that there came into being a coincidence of recollection of a somewhat curious incident between the appellant and Mr Pearson.

During his trial the appellant went back on the main part of his story, and especially that part of it wherein he had confessed to murdering Mr Fisher. He did not in so many words say that the story had been forced out of him. He clearly wished to leave the impression with the jury that he had not been telling a story in which he himself believed, because it was untrue.

There was an incident which is of some importance in this case during the course of the prosecution. It took place when Mr Pearson was going to testify. Mr Beckman who appeared then for the appellant, and who has appeared for him here today, invited the judge to give permission for the appellant to be taken below stairs whilst Mr Pearson was giving evidence. The reason for that was that Mr Beckman, perfectly properly, did not wish Mr Pearson by inadvertence or by design or by accident (no matter how) to have the opportunity during the course of evidence in chief or in cross-examination of looking across the courtroom and saying, "That man in the dock is the man who came into my off licence in the company of the victim, the deceased, a short while before the murder".

As I have already said, if the prosecution had not made the matter clear in opening, they certainly began to make it clear at a later stage that it was part of their case that the appellant was the Irishman said by Mr Pearson to have been in company with the deceased before the murder. Mr Pearson's description, as given originally in 1975 (and adhered to in 1984) of that Irishman did not fit the description which could properly be applied to the appellant, who is not here today by his own choice. The

appellant, we are told, is tall, slim and has a long nose; whereas the Irishman referred to was said by Mr Pearson to be of mid-height (5'8" -9"), stocky in build and ruddy in the face.

After the appellant had in every sense completed his evidence Mr Beckman decided to make another application to the judge. He asked that he, Mr Beckman, should be permitted to call Mr Pearson as part of the defence case. Whether Mr Pearson had been released after giving evidence is neither here nor there, but he had completed his testimony in the prosecution's case. There was then a discussion, as we have seen from the transcript, between Mr Beckman, Mr Coombe (who was then, together with Mr Cassel, appearing for the prosecution) and the judge as to the propriety of a witness for the prosecution giving evidence later in the trial for the defence. It was a novel experience, said the judge, for him to be asked to consider such a matter. We feel bound to say it is equally novel to us. What was suggested should be done was that Mr Beckman's solicitor should interview Mr Pearson and take a statement from him. He was to be shown photographs, on the one hand, of the appellant and, upon the other, of a person whose identity we knew nothing about, but who seems to have a ruddy complexion and is stocky in appearance. The judge came to the conclusion that he would not permit Mr Pearson to be called by the defence as a witness. He would, however, he said sympathetically receive an application that Mr Pearson be re-called for the purpose of being further cross-examined by Mr Beckman. That this is a course which can be adopted in appropriate circumstances with the leave of the judge there is no doubt whatsoever. As to whether or not it will be permitted a judge in his discretion will always decide having regard to the circumstances of the case; especially of course, having regard to what is the justice of the matter as it appears to him. The judge enquired whether or not it was agreeable to Mr Beckman if he allowed this witness, Mr Pearson, to be interviewed that a representative of the prosecution be

present. Mr Beckman objected to that. He said he had no objection to somebody independent being present, but in no circumstances would he be a party to the interview of this witness being conducted by his solicitor with a police officer present on behalf of the prosecution.

The judge considered various arguments and the case of <u>Harmony Shipping Co, SA v Davis and Others 1979, 3 All E.R. 177</u>. He was referred to the judgement of Lord Denning in that case, to articles which appear in the Law Society Gazette and a Code of Conduct for Solicitors. It is apparent from what appears in the judgement in <u>Harmony Shipping</u> and from those articles that the authors of the articles and Lord Denning were pointing out that there is no property in a witness. Nobody here questions that. The circumstances, however, in which the point (which was a very different one from that which is raised here) arose in <u>Harmony Shipping</u> do not, so it seems to us, assist us to resolve the issue upon which the judge was called to rule. That was not a criminal case for a start and it did not involve the circumstances of a witness having actually been called to give evidence, moreover called to give it in a criminal trial as part of the prosecution's case.

The judge in making his ruling – and with this we are in entire agreement – having referred to what had been said in the <u>Harmony Shipping</u> case and the argument, went on to say:

"This is a more detailed way of stating what is conventionally put in the short sentence, "There is no property in a witness". That, of course, is true. However" –and this is the procedure and practice of the courts of England and Wales". Later he stated, "If an application is made in this case for Mr Pearson to be recalled then I will consider it on its merits and exercise my discretion. Provided that I know for what purpose it is required, and provided that I know that there is good reason why the matter was not put when he was here before, then I should think that it is almost certain that I would exercise my discretion in allowing him to be recalled. That application

has not yet been made". He declined to allow the witness to be interviewed save in the presence of a representative of the prosecution and he declined to permit this witness to be called as a witness for the defence in any circumstances. The application referred to by the judge in the last quotation read from his ruling was never made, so no new further evidence came from Mr Pearson.

Since the trial this witness has sworn on affidavit in the course of which he recalled giving evidence for the prosecution. As to two photographs which he was shown, namely one of the appellant, and another of somebody called McManus, he said, "The person I referred to in my evidence had been a big, well-built man and had certainly not been as thin as the man in the first photograph". That was of the appellant. So what he was in fact saying was, "The man I was talking about as having been in company with the deceased, before the murder that is, was not the appellant". Presumably Mr Pearson would have said that in the course of the trial had he been asked, but he was not asked. It would have been the simplest thing in the world during the course of the prosecution's evidence, with the appellant downstairs, for those two photographs to have been shown to him and to have been asked whether either one of those two people was the person to whom he had referred as being the companion of the deceased. Why that simple and usual course in cases of identity was not adopted is beyond our comprehension. If the photographs in existence after the trial were not then in existence, others no doubt could have been provided. The police had any amount of photographs which could have been handed over to the defence for that purpose.

The leading contention by Mr Beckman is that he was wholly unaware until the appellant was being cross-examined, or some such stage as that – very late in the trial any way - that the prosecution was nailing its colours to the mast of the appellant having been the companion of the deceased before the murder. That, he says, surprised him vastly. There was no indication by counsel who opened

the matter for the prosecution that that is what their basic contention was on that issue. We do not feel in the least inclined to be drawn into the controversy as to what exactly was said by counsel for the prosecution in opening. The recollection on the prosecution side is that something to the effect that the appellant was that man was said in opening. Mr Beckman says he has no recollection of it. He was there of course, as indeed was Mr Cassel. He says that others who were there have the same recollection as he has. Whatever be the position as to that, we are not persuaded in the least that it was not outside the anticipation of Mr Beckman that the prosecution would at some stage of the trial (if not at the outset) have been saying that there was at least a possibility, if not a high probability, that the companion of the deceased shortly before the murder was the appellant. One has only to look at the contents of the second statement made by Mr Pearson, namely that made in 1983, and compare that with his original statement, and compare those with what the appellant told the police on interview when he confessed to this murder, we think, to appreciate that it was inevitable that the prosecution would be putting to the appellant that he not only knew the deceased but had been his companion at the time referred to. We do not therefore feel able to accept Mr Beckman's assertion that no sensible counsel placed in the position he was could have envisaged the prosecution taking such a stand as that. So that all other considerations put aside – and we shall turn to them shortly – we fail to see how the judge could have reacted in this case in any other way than he did to the suggestion that this was all a surprise to the defence and could not have been anticipated.

Mr Beckman further contends that there are here some very disquieting features. Firstly, there are the inconsistencies between what the appellant said he actually did to the deceased and what the pathologist found had happened to him by way of injury, taking account of course of the opinions expressed by the pathologist to which I have already referred. We have them well in mind. There is

not any doubt at all that there were inconsistencies. There was an absence of injury in parts of the body where the appellant said he had inflicted injury. The weapon which the appellant said he used did not compare with the kind of weapon which the pathologist said must have been used to inflict one or more injuries, and so on. All these matters were jury points. Mr Beckman with his conspicuous ability could not have failed to have made the most of them in his final address. The judge certainly did not overlook them. In a number of places in the summing up one finds reference to his reminding the jury of the need for care in considering the inconsistencies between the story of this man and the evidence of the pathologist.

Then, Mr Beckman says that the description of the man who Mr Pearson said accompanied the appellant before the murder could have fitted another Irishman seen about the place. We dare say it could. As to the difference between the description provided by Mr Pearson and the appearance of the appellant the judge reminded the jury of the need to bear that in mind too when they were considering whether or not they would accept as true and accurate the confession made to the police by the appellant. That too was a jury point which they could not possibly, in our judgement, have lost sight of in view of what Mr Beckman must have said to them, and, what is more important, what the judge had to say to them in his summing-up.

There was no identification parade either in 1975 or in 1983. In 1975 it is difficult to see why there should have been seeing that the appellant was not at any time under arrest, nor, so far as we know, a suspect in the sense that the police were sufficiently impressed by his possible implication as to have him stand in a line. Come 1983, doubtless the need for an identification parade became subservient to the doubts that were held as to the effectiveness of that kind of identification having regard to the years which had rolled by. I should say for completion of that subject that the question of the absence of an identification parade was another matter which the jury were invited to look at.

That brings us back to this question of whether the judge was right to deny Mr Beckman the opportunity of calling Mr Pearson as a witness for the defence. We wish to say as emphatically as we can that once a witness has given evidence for the prosecution at a criminal trial it becomes always a matter for the discretion of the judge (a) whether or not that witness should be interviewed either by the prosecution or the defence for the purpose of being recalled, and (b) the circumstances in which if a statement is to be taken from him, that statement will be produced and used. So that here what the judge was doing was faithfully observing the practice and procedure of the court as known to judges and practitioners alike and conforming to it in a way which was wholly appropriate to the circumstances of this case.

The trite saying that there is no property in a witness has no application once a witness has given evidence for the prosecution in a criminal case and the question as to whether or not he should be interviewed later on and called arises. The judge controls the trial. He controls too the witnesses who give evidence in it and only by his leave will a witness be interfered with after he has given evidence, either because a statement is sought from him by the prosecution or the defence for any purpose.

The last point which arises out of this particular issue is equally simple, in our judgement, to dispose of. We are in no doubt that it is never permissible in a criminal case for a witness who has given evidence for the prosecution to be called for the defence. He may be recalled with the leave of the judge for the purpose of being cross-examined, but we repeat he may never be called by the defence as a witness. In that respect the judge had no discretion to exercise at all.

For those reasons this appeal is dismissed.

APPENDIX TWO

Alleged British Serial Killers

No.	Facts	Serial Killer?	Convicted	Suspected
1.	Stephen Akinmurele (also known as the 'cul-de-sac killer') had a pathological hatred of old people. He was charged with the murder of five elderly people in quiet suburban streets in Blackpool and the Isle of Man between 1995 and 1998, and police suspected him of two further murders. Akinmurele committed suicide in Manchester's Strangeways Prison while on remand awaiting trial and was never convicted. Therefore, technically, he does not meet the criteria of a serial killer.	No	0	7
2.	Beverley Allitt (also known as the 'angel of death') was convicted of killing four babies and injuring at least nine others over a period of 59 days between February and April 1991. The murders took place in the children's ward at Grantham and Kesteven Hospital, Lincolnshire, where Allitt was employed as a state enrolled nurse. She was sentenced to life imprisonment in 1991. Having been convicted of 'only' killing four (it is generally agreed that there needs to be five murders for the assailant to be dubbed a serial killer) Allitt also technically fails to meet the criteria of a serial killer.	No	4	4
3.	Levi Bellfield (also known as the 'bus stop stalker') murdered Amanda (Millie) Dowler in 2002 and went on to commit two more fatal hammer attacks on young women in south-west London in 2003 and 2004. He was convicted of three murders and one attempted murder and has been sentenced to a whole life term. He is suspected of several more attacks on young women. Having been convicted of 'only' three murders, Bellfield cannot be called a serial killer.	No	3	3+
4.	Robert Black was convicted of the kidnap and murder of four girls aged from five to 11 between 1981 and 1986. The Scot is also suspected of unsolved child murders across Europe dating back to 1969. On 19 May 1994, Black was found guilty on all counts and was sentenced to life imprisonment with a recommendation that he should serve at least 35 years. On 16 December 2009, Black was charged with the murder of 9-year-old Jennifer Cardy and was given a further life sentence. At the time of his death on 21 January 2016, he was about to be charged with the murder of 13-year-old Genette Tate. Black does qualify as a serial killer.	Yes	5	17

5 and 6.	Ian Brady and Myra Hindley (also known as the 'Moors murderers') murdered five children, aged 10 to 17 between July 1963 and October 1965. Two of their victims were found in graves on Saddleworth Moor, near Manchester. On 6 May 1966 Brady and Hindley were convicted of three murders and sentenced to life imprisonment, narrowly escaping the death penalty, which had been withdrawn while they were on remand. On 1 July 1987 the body of a fourth victim was discovered on Saddleworth Moor. The body of their fifth victim, Keith Bennett, has never been found. As Brady and Hindley were already serving whole-life terms, there was no point in convicting them for these two murders and with only three convictions, they don't fit the profile of serial killers. Hindley died in prison on 15 November 2002 and Brady, who is force fed, having been on hunger strike for many years, is kept in a high-security psychiatric hospital.	No	3 5	
7.	Mary Ann Britland claimed to have had a mouse infestation in her home in Ashton-Under-Lyne in February 1886. Accordingly she bought packets of Harrison's Vermin Killer but as this contained both strychnine and arsenic, she was required to sign the poison register. The next month she murdered her daughter Elizabeth but the doctor put the death down to natural causes. Britland claimed £10 on her life insurance policy. Her next victim was her husband Thomas and again she claimed on the life insurance. Her third and final victim was her lover's wife. Following her trial in Manchester, she became the first woman to be hanged at Strangeways Prison on 9 August 1886. Having 'only' been convicted of three murders, Britland does not meet the definition of a serial killer.	No	3 3	
8.	Peter Bryan is a cannibal who was institutionalized in a psychiatric hospital for a fatal hammer attack on a woman in 1993. Despite claims he had made 'good progress', he was re-apprehended for murdering a friend with a hammer in 2004. When police came to his flat, he was cooking the dead man's brain in a frying pan. Two months after being returned to hospital, he battered a fellow patient to death and said if he hadn't been interrupted he would have eaten his flesh. On 15 March 2005 at the Old Bailey, Bryan pleaded guilty to two counts of manslaughter on the grounds of diminished responsibility and was sentenced to life imprisonment. This does not meet the requirements for classification as a serial killer.	No	2 3	

9 and 10.	William Burke and William Hare (popularly known as Burke and Hare) were notorious body snatchers in Edinburgh in 1828. Assisted by Burke's mistress, Helen McDougal and Hare's wife, Margaret Laird, they delivered 16 dead bodies to Dr Robert Knox at the Edinburgh Medical School. As medical science flourished, the demand for cadavers rose sharply but the main source – the bodies of executed criminals – dried up owing to a reduction in the number of executions. Burke and Hare met the demand, firstly by grave robbing from local cemeteries and then, as security in cemeteries improved, by killing vagrants for the fees that they received at the medical school. Eventually, Burke, Hare and McDougal were each charged with three murders, but the case against them was considered weak. The Lord Advocate invited Hare to give King's evidence to convict the others in exchange for his own release. Burke was convicted and hanged. Hare spent the rest of his life running away from violent mobs trying to impose a similar, but unlawful, penalty on him. A conviction for just three murders did not qualify any of those responsible to be called serial killers.	No	Burke 3 <16 Hare 0 <16
11.	George Chapman was born Seweryn Antonowicz Klosowski in Nargornak in Poland and moved to London as an adult. Between 1901 and 1903, he was arrested for killing three women who posed as his wives by poisoning them with the compound tartar emetic. At the time, an indictment for murder could only contain one count as those convicted could only be executed once. Chapman was therefore charged only with the murder of his final victim, Maud Marsh. He was convicted on March 19, 1903 and hanged at Wandsworth Prison on April 7, 1903. A single conviction for murder does not qualify Chapman as a serial killer. However, he is suspected by some authorities of being the notorious multiple murderer 'Jack the ripper', in which case his head count would be far greater.	No	3 <15
12.	John Childs, also known as Bruce Childs, was arrested for armed robbery in 1979 and immediately confessed to killing six people. Between 1974 and 1978 he worked as a contract killer and despite none of the bodies ever being found, he was convicted of six murders in 1979 and became known as the most prolific hit man in the UK. He implicated two others in the murders, but they were released in 2003 after a judge ruled Childs to be a pathological liar. On 4 December 1979, Childs was convicted and sentenced to six concurrent life sentences and a whole life term. Accordingly, Childs is a serial killer.	Yes	6 6

		No	1 / 8
13.	John Reginald Halliday Christie lived at 10 Rillington Place, Notting Hill, London, with the Evans family as his tenants. When, in 1949, Beryl Evans and her young daughter Geraldine were found strangled, Christie was a key prosecution witness and Beryl's husband, Timothy, was charged with both murders, convicted of his daughter's murder and hanged. Christie moved out of Rillington Place in March 1953 and shortly afterwards the bodies of three other women were discovered hidden in an alcove in the kitchen and Christie's wife's body was found beneath the floorboards in the front room. Christie, who confessed to killing two women in 1943 and 1944, was arrested, convicted of his wife's murder and hanged. He usually strangled his victims after he had rendered them unconscious with domestic gas and some he raped as they lay unconscious. The wrongful execution of Timothy Evans led to the abolition of capital punishment. Despite the evidence against him, Christie was charged with just one murder and does not therefore qualify as a serial killer.	No	0 / 4
14.	Dr Robert George Clements was from Belfast, Northern Ireland and worked in Lancashire as a physician and surgeon. He was suspected of the murder of his fourth wife, who died of morphine poisoning. His first three wives also predeceased him, raising suspicions that he had murdered them too. Clements committed suicide with an overdose of morphine before he was caught and never stood trial. He does not, therefore, qualify as a serial killer.	No	4 / 4
15.	John Cooper (also known as the 'wildman' and the 'bullseye killer') burgled a three-storey farmhouse in Scoveston Park, Milford Haven on 22 December 1985, shooting and killing brother and sister, Richard and Helen Thomas, and later burning down the house. In 1989 Cooper used the same shotgun to kill Peter and Gwenda Dixon while they were taking a walk on a coastal path. In September 2011 he was convicted of all four murders and sentenced to life imprisonment, but this is not enough to define him as a serial killer.	No	1 / <21?
16.	Mary Ann Cotton (née Robson) is sometimes claimed to have been Britain's first serial killer. She was believed to have murdered up to 21 people, including 11 of her 13 children, mainly by arsenic poisoning. Cotton was hanged at Durham County Gaol on 24 March 1873, but as the law at this time only allowed a single indictment for murder, she technically does not qualify as a serial killer.		

No.	Details	Serial killer?		
17.	Dr Thomas Neill Cream (also known as the 'Lambeth poisoner') was a Scottish-Canadian serial killer, who claimed his first proven victims in the United States and the rest in England, with others possibly in Canada and Scotland. Cream, who poisoned his victims, was hanged on 15 November 1892 at Newgate Prison, but as the law at this time only allowed a single indictment for murder, he technically does not qualify as a serial killer.		1	<10?
18.	Dale Christopher Cregan is a convicted drug dealer from Manchester who, on 25 May 2012, shot dead a rival in a pub in Droylsden and tried to kill three other men. Two months later he killed his first victim's father by shooting and throwing a hand grenade at him. The next month he made an emergency call to the police and when constables Nicola Hughes, 23, and Fiona Bone, 32, arrived, Cregan shot and then threw an M75 hand grenade at them. Both officers were killed by at least eight bullets as Cregan fired 32 shots in 31 seconds. He was sentenced to a whole life term of imprisonment for the four murders, but does not qualify as a serial killer.	No	4	4
19.	Frederick Bailey Deeming was an English-born Australian gasfitter, responsible for the murder of his first wife Marie and his four children, in Rainhill, Merseyside, on or about 26 July 1891, and a second wife, Emily Mather, in Windsor, Melbourne, Australia on 24 December 1891. He was executed for her murder in May 1892. As the law at this time only allowed a single indictment for murder, he technically does not qualify as a serial killer. Some believed he could have been 'Jack the ripper' and he has gone down in notoriety with his death mask on display at The Old Melbourne Gaol museum and at the Black Museum at New Scotland Yard.	No	1	6
20.	Joanna Dennehy set out on a killing spree in Peterborough and Hereford in March 2013 with the assistance of three men, who were believed to be her lovers. When the bodies of three other men, who had died from stab wounds to the heart, were found in ditches around Peterborough, Dennehy was arrested, convicted and sentenced to a whole life term of imprisonment. She does not qualify as a serial killer.	No	3	3

21 and 22.	John Duffy and David Mulcahy (also known as the 'railway rapists' and the 'railway killers') are two British rapists and killers who together attacked numerous women at railway stations in the south of England between 1982 and 1986. Duffy went on trial in February 1988 and was convicted of two murders and four rapes. Mulcahy was convicted of three murders and seven rapes and handed three life sentences, with a 30-year recommendation. Later Duffy was convicted of 17 more rapes and received a further 12 years imprisonment. Neither was convicted of the five murders required to qualify as a serial killer.	No	Duffy 2 Mulcahy 3
23.	Amelia Elizabeth Dyer (née Hobley) was a Victorian baby farmer who cared for infants in return for money. She was tried and hanged for one murder, but there is little doubt she was responsible for many more, possibly 400 or more, over a period of 20 years. She was hanged at Newgate Prison on Wednesday, 10 June 1896, but does not qualify as a serial killer.	No	1 400
24.	Kenneth Erskine (also known as the 'Stockwell strangler') murdered at least seven elderly people by breaking into their homes and strangling them. He frequently sexually assaulted them as well. Convicted of murdering seven pensioners in 1988, he was sentenced to life imprisonment with a recommendation that he serve 40 years. Since his conviction Erskine has been assessed as mentally disordered and transferred to Broadmoor Hospital for the criminally insane, but his seven convictions for murder remain and he qualifies as a serial killer.	Yes	7 7+
25 and 26.	Catherine Flanagan and Margaret Higgins (also known as the 'black widows of Liverpool') were Irish sisters who were convicted of poisoning and murdering one person in Liverpool and were suspected of at least three more deaths. The women collected a type of life insurance called a burial society pay out, on each death. Though Flanagan evaded police for a time, both sisters were eventually caught and convicted of one of the murders. Accordingly, they do not qualify as serial killers. They were both hanged on the same day in 1884 at Kirkdale Prison. It is believed they may have been part of a larger 'murder for money' network of black widows.	No	1 4+
27.	Steven John Grieveson (also known as the 'Sunderland strangler') murdered three teenage boys in Sunderland between 1993 and 1994 in order to conceal his homosexuality. He was convicted on 28 February 1996 and ordered to serve at least 35 years for the three murders. In October 2013, he was charged with another murder, which had taken place in 1990. Four convictions for murder do not qualify Grieveson as a serial killer.	No	4 4

No.	Description			
28.	Stephen Griffiths (also known as the 'crossbow cannibal') killed three female sex workers in Bradford, West Yorkshire in 2009 and 2010. On 21 December 2010, Griffiths was convicted of all three murders and was sentenced to a whole life tariff. Three convictions for murder do not qualify Griffiths as a serial killer.	No	3	3
29.	John George Haigh (also known as the 'acid bath murderer' and the 'vampire of London') was active in England during the 1940s. He was convicted of six murders, but claimed to have killed nine people. He used the acid baths not to kill his victims but to dispose of their bodies, in the mistaken belief that he could not be convicted in the absence of a body. He was executed at Wandsworth Prison in 1949. Six convictions qualify Haigh as a serial killer.	Yes	6	9
30.	Archibald Thomson Hall, aka Roy Fontaine (also known as the 'monster butler' and the 'killer butler') was a thief who stole from his employers – members of the British aristocracy – before killing them. He worked with an accomplice, Michael Kitto, and was charged with five murders, convicted of four, with one left on file. At the time of his death aged 78 in 2002, he was the oldest British prisoner to be serving a whole-life tariff. Four convictions for murder do not qualify Hall as a serial killer.	No	4	5
31.	Anthony Hardy (also known as the 'Camden ripper') was convicted of the murder and mutilation of three prostitutes between December 2000 and December 2002. It is believed that Hardy may have committed as many as nine murders. He was sentenced to a whole life term but does not qualify as a serial killer.	No	3	9
32.	Trevor Hardy (also known as the 'beast of Manchester') killed three teenage girls in Manchester between 1974 and 1976. He died after suffering a heart attack at Wakefield Prison. Three murders do not qualify him as a serial killer.	No	3	3
33.	Philip Herbert (also known as the 'infamous Earl of Pembroke') was a 17th century nobleman convicted of manslaughter but discharged. He later killed the prosecutor and received a pardon for a third murder. He was never convicted of murder, so is not a serial killer.	No	0	3

No.	Description	Serial killer?		
34.	Colin Ireland (also known as the 'gay slayer') killed five men from the Coleherne pub in Kensington, London in the early 1990s. His victims were all homosexuals seeking partners for sadomasochistic activity. Ireland, who claimed to be heterosexual and said the murders weren't sexually motivated was jailed for life in December 1993 and remained imprisoned until his death in February 2012, at the age of 57. His conviction for five murders qualifies Ireland as a serial killer.	Yes	5	5
35.	Kieran Patrick Kelly (also known as the 'London Underground serial killer') was a member of the south-west London vagrant community. Between 1953 and 1983, Kelly was charged (and then acquitted) separately of eight murders by eight separate teams of detectives. The acquittals were usually due to the prosecution's inability to show that he had a motive. Kelly pushed his victims under London Underground trains or poisoned them with white spirit. In 1983 he admitted 15 more murders and a year later was convicted of one charge of murder and one of manslaughter. The other matters were left on file. In 2015, seven more potential victims were identified. Despite being suspected of murdering 31 people, with just two convictions Kelly doesn't qualify as a serial killer.	No	2	31
36.	Robin Ligus was a mental patient and drug addict convicted of robbing and bludgeoning three men to death with an iron bar in Shropshire in 1994. He was declared unfit to plead and detained indefinitely in a mental hospital. With no convictions, Ligus does not qualify as a serial killer.	No	0	3
37.	Michael Lupo (also known as 'wolf man') was an Italian-born, British-based hairdresser who claimed to have had 4,000 male lovers. When he discovered he was HIV positive he responded by killing four men. He was convicted of four murders and two attempted murders in 1986 and died in Durham Prison of an AIDS-related illness in 1995. With just four convictions for murder, Lupo cannot be classified as a serial killer.	No	4	4
38.	Patrick Mackay (also known as the 'psychopath' and the 'devil's disciple') was obsessed with Nazism. His mother arranged for him to be befriended by a Catholic priest but Mackay stole £30 from him and killed him with an axe. He then robbed and murdered a number of women. He was charged with five murders, convicted of three, but admitted to killing 11. In November 1975 he was convicted of manslaughter (due to diminished responsibility) and sentenced to life imprisonment and a whole life term. Three convictions for manslaughter do not qualify Mackay as a serial killer.	No	3	11

39.	Peter Thomas Anthony Manuel (also known as the 'beast of Birkenshaw') was an American-born Scot who was convicted of murdering seven people across Lanarkshire and southern Scotland between 1956 and his arrest in January 1958. He is believed to have murdered two more. He was hanged at Glasgow's Barlinnie Prison and was one of the last prisoners to be executed in Scotland. Manuel qualifies as a serial killer.	Yes	7	9
40.	Robert John Maudsley, (also known as 'Hannibal the cannibal') garrotted a man who picked him up for sex in 1973, after the man showed him pictures of children he had sexually abused. Maudsley was arrested, sentenced to a whole life term and sent to Broadmoor Hospital. In 1977, Maudsley and another inmate took a third patient – a convicted child molester – hostage and slowly tortured him to death. After this incident, Maudsley was convicted of manslaughter and sent to Wakefield Prison. One afternoon in 1978 Maudsley killed two fellow prisoners. He invited the first to his cell where he garrotted and stabbed him before hiding his body under his bed. He attempted to lure other prisoners into his cell but when they refused, he went on the prowl, eventually cornering and stabbing and killing a second prisoner. Maudsley then calmly walked into the prison officer's room, placed the dagger on the table and told him that the next roll call would be two short. Considered too dangerous for a normal cell, he lives in a 'glass cage', similar to the one housing Hannibal Lecter in *The Silence of the Lambs*, in the basement of Wakefield Prison. With one conviction for murder and one for manslaughter, Maudsley does not qualify as a serial killer.	No	2	4
41.	Peter Moore (also known as the 'man in black') is a Welshman, who between September and December 1995 stabbed to death and mutilated four homosexual men 'for fun'. He was sentenced to life imprisonment in November 1996. He does not qualify as a serial killer.	No	4	4
42.	Raymond Leslie Morris (also known as the 'A34 killer') was a Staffordshire paedophile who sexually abused and murdered girls aged between five and nine. He was convicted of one murder but is strongly suspected of having committed at least two more. On 16 November 1968, Morris was found guilty of the rape and murder of 7-year-old Christine Darby and was sentenced to life imprisonment. He died at Preston Prison on 11 March 2014, aged 84. With only one conviction for murder, he cannot be called a serial killer.	No	1	3+

43.	Robert Clive Napper (also known as the 'green chain rapist' and the 'Plumstead ripper') sexually attacked and murdered two young women in the presence of their young children and also killed one of the children. One of his victims was Rachel Nickell, who was stabbed 49 times on Wimbledon Common in 1992 and lay dying while her 2-year-old son clung to her body. In 2008, Napper claimed responsibility. He was convicted of two murders and one of manslaughter (on the grounds of diminished responsibility, due to his mental health problems) and was remanded to Broadmoor Hospital indefinitely. He cannot be classified as a serial killer.	No	3 3
44.	Donald Neilson (born Donald Nappey and also known as the 'black panther') was an armed robber who murdered four people. Following three murders committed during robberies of sub-post offices from 1971 to 1974, he moved to kidnapping and made Lesley Whittle, an heiress from Highley, Shropshire, his first victim in early 1975, hiding her in underground drainage channels in Tamworth, Staffordshire. He was arrested later that year and sentenced to life imprisonment in 1976, remaining in prison until his death 35 years later. His four convictions for murder do not make him a serial killer.	No	4 4
45.	Dennis Andrew Nilsen (also known as the 'Muswell Hill murderer' and the 'kindly killer') lured young homosexual men to his home and then murdered them by strangulation, sometimes accompanied by drowning. Following the murders, Nilsen bathed and dressed the victims' bodies and sometimes engaged in sexual acts with them. He kept the bodies for a while before dissecting and disposing of the remains via a bonfire, or by flushing them down the toilet. In all, he is suspected of 16 murders. Nilsen was convicted of six murders and two attempted murders and on 4 November 1983 he was sentenced to life imprisonment. He qualifies as a serial killer.	Yes	6 16
46.	Colin Campbell Norris was a Scottish-born nurse who murdered four elderly patients at Leeds General Infirmary and St James's Hospital in Leeds in 2001 and 2002. In the course of their investigation, the police looked into 72 suspicious deaths. On 3 March 2008 Norris was convicted of the murder of four women and the attempted murder of a fifth. He was sentenced to life imprisonment, and ordered to serve a minimum term of 30 years. He does not qualify as a serial killer.	No	4 72

#	Description	Serial Killer	No. 1	No. 2
47.	Dr William Palmer (also known as the 'Rugeley poisoner' or the 'prince of poisoners') was an English doctor who was convicted of the 1855 murder of his friend John Cook, and was hanged in public the following year. He had poisoned Cook with strychnine, and was suspected of poisoning several other people including his brother and his mother-in-law, as well as four of his children who died of 'convulsions' before their first birthdays. Palmer made large sums of money from the deaths of his wife and brother after collecting on life insurance, and by defrauding his wealthy mother out of thousands of pounds, all of which he lost through gambling on horses. Charles Dickens called Palmer 'the greatest villain that ever stood in the Old Bailey.' With one conviction for murder, Palmer is not a serial killer.	No	1	7
48.	Dr Edward William Pritchard was an English doctor, living in Glasgow, who was convicted of murdering his wife and mother-in-law by poisoning. He was also suspected of a third murder of a servant, but was never tried for it. He was the last person to be publicly executed in Glasgow in 1865. Pritchard cannot be defined as a serial killer.	No	2	3
49.	Harold Fredrick Shipman (also known as 'Dr Death and 'the angel of death') was a British doctor and one of the most prolific serial killers in recorded history. In July 2002, The Shipman Inquiry concluded that he had killed at least 218 of his patients (about 80 per cent of whom were women) between 1975 and 1998, during which time he practised as a general practitioner in Todmorden, West Yorkshire (1974–1975) and Hyde, Greater Manchester (1977–1998). On 31 January 2000, a jury found Shipman guilty of 15 charges of murder. He was sentenced to life imprisonment with a recommendation that he never be released. On 13 January 2004, on the eve of his 58th birthday, Shipman hanged himself in his cell at Wakefield Prison. Subsequent enquiries have suggested that he may have been responsible for the deaths of 457 of his patients. As a result of his conviction, the procedure surrounding the reporting and recording of death in the UK has been reviewed, and revised. Shipman meets the requirements to be classified as a serial killer.	Yes	15	457
50.	Angus Sinclair was accused of killing two 17-year-old girls in 1977 in what became known as the 'world's end murders' because the girls were last seen leaving the World's End pub in Edinburgh. In 2007, he was acquitted in controversial circumstances but retried and convicted in 2014. He had earlier been convicted of two other murders and is thought to have killed four other women. Sinclair is serving the longest sentence ever handed down by a Scottish court but with four convictions, he does not count as a serial killer.	No	4	8

No.	Description	Serial killer	Count
51.	George Joseph Smith (also known as the 'brides in the bath murderer') travelled around the country, seeking out women with money, marrying them, insuring them and then murdering them. He developed a technique of surprising the women whilst they were bathing and pulling their feet until their head slipped under the water and they drowned. He was convicted of the murder of three of his wives at the Old Bailey and hanged at Maidstone Prison on 13 August 1915. He does not meet the criteria for a serial killer.	No	3 3
52.	John Thomas Straffen killed two girls, aged five and nine, in Bath in July and August 1951 'in order to annoy the police' whom he hated. He was found to be unfit to plead and was sent to Broadmoor Hospital. In April 1952 he escaped from Broadmoor and within a couple of hours had murdered another 5-year-old girl. This time he was convicted and sentenced to death. The home secretary reduced the sentence to life imprisonment and Straffen died at Frankland Prison in Durham on 19 November 2007 aged 77, when he'd been imprisoned for a British record of 55 years. With one conviction, Straffen does not qualify as a serial killer.	No	1 3
53.	Peter William Sutcliffe (aka Peter William Coonan, also known as the 'Yorkshire ripper') was convicted of murdering and butchering 13 women and attempting to murder seven others between 1976 and 1981. His obsession with killing female sex workers seems to have originated with an argument over payment, but he later claimed to have been sent on a mission by the voice of God. After his arrest in January 1981 for driving with false number plates, he confessed that he was the perpetrator. At his trial he pleaded not guilty to murder on grounds of diminished responsibility owing to a diagnosis of paranoid schizophrenia but this defence was rejected. He is serving 20 concurrent sentences of life imprisonment, currently in Broadmoor. The High Court dismissed an appeal by Sutcliffe in 2010, confirming that he would never be released from prison. Sutcliffe is a serial killer.	Yes	13 13
54.	Peter Britton Tobin was sentenced to 10 years imprisonment for a double rape committed in 1993, and was released in 2004. In 2007, he was sentenced to life with a minimum of 21 years for a rape and murder in Glasgow in 2006. Skeletal remains of a further two women who went missing in 1991 were subsequently found at his former home in Margate, Kent. Tobin was convicted of these murders in December 2008 and December 2009 and his minimum sentence was increased to 30 years. Tobin cannot be classified as a serial killer.	No	3 3+

55.	Thomas Griffiths Wainewright was a London-based artist, author, and dandy. In 1830 he insured the life of his sister-in-law, Helen Abercrombie, for a sum of £18,000 and when she died a few months later, payment was refused on the grounds of misrepresentation. Wainewright retired to Boulogne, France, where he was found in possession of strychnine and it was widely suspected that he had poisoned not only his sister-in-law but also his uncle, mother-in-law and a Norfolk friend, although this was never proved. He returned to London in 1837 but was arrested on a charge of forgery, which had taken place 13 years earlier, and he was transported to a penal colony in Australia. There he admitted killing Abercrombie saying: 'it was a dreadful thing to do, but she had very thick ankles.' He died of apoplexy on 17 August 1847. With no convictions for murder, he cannot be classified as a serial killer.	No	0 / 4
56.	Margaret Waters was a baby farmer who took in other women's children for money, a practice often resulting in infanticide. She drugged and starved the infants in her care and is believed to have killed at least 19 children. She was charged with five counts of murder as well as neglect and conspiracy but was convicted of murdering just one baby, John Walter Cowen. She was hanged at Horsemonger Lane Gaol (also known as Surrey County Gaol) on 11 October 1870. Having been convicted of just one murder, Waters cannot be classed as a serial killer.	No	1 / 19
57 and 58.	Frederick Walter Stephen West and Rosemary West (also known as the 'house of horrors murderers') lived together at 25 Midland Road and later at 25 Cromwell Street, Gloucester. Between 1967 and 1987 (but mainly between May 1973 and August 1979) they tortured and raped many young women and girls, murdering at least 11 of them, including their own daughter. The crimes often occurred in the couple's homes, with many bodies buried at the properties. The pair were finally apprehended and charged in 1994. Fred committed suicide before going to trial while Rose was jailed for life in November 1995 after having been found guilty of 10 counts of murder. Their house at Cromwell Street was demolished in 1996. As he never went to trial, Fred West cannot be defined as a serial killer but Rosemary West can.	Rose yes / Fred no	Rose 10 / Fred 0 / Both 10+
59.	Catherine Wilson was a Victorian nurse who worked in Spalding, Lincolnshire before moving to Kirkby, Cumbria. She poisoned her victims after encouraging them to leave her money in their wills. She was hanged for one murder, but was generally thought at the time to have committed six others. She was described privately by the sentencing judge as 'the greatest criminal that ever lived.' With one conviction, Wilson cannot be defined as a serial killer.	No	1 / 7

#	Description			
60.	Mary Elizabeth Wilson, née Cassidy (also known as the 'merry widow of Windy Nook'), married and lost four husbands between 1914 and 1957. Her 'luck' was the subject of some debate locally but it was her own sense of humour that led to her downfall. She joked at her last wedding reception that the leftover sandwiches would be fresh enough to use in the next funeral. She had also asked for a trade discount from the local undertaker for providing him with plenty of business. When her fourth husband died she didn't even bother to attend the funeral. With the police suspicious, the bodies were exhumed and beetle poison was found to have killed her first two husbands while phosphorous killed the last two. At Leeds Crown Court she was convicted of murdering her first two husbands but it was thought unnecessary to charge her with the murder of the others. She was sentenced to death but in view of her age (64) the sentence was commuted to life imprisonment. She died in Holloway Prison in 1963. With two convictions, Wilson does not qualify as a serial killer.	No	2	4
61.	Steven Gerald James Wright (also known as the 'Suffolk strangler' and the 'Ipswich ripper') murdered five prostitutes in Ipswich between 30 October and 10 December 2006. Their bodies were discovered naked but there were no signs of sexual assault. Wright appeared at Ipswich Crown Court and despite pleading not guilty to the charges, he was convicted of all five murders on 22 February 2008. Wright, who has been linked to other unsolved crimes including the disappearance of Suzy Lamplugh in 1986, was sentenced to a whole life term. Wright is a serial killer.	Yes	5	5
62.	Graham Frederick Young (also known as the 'teacup poisoner') was sent to Broadmoor in 1962 after poisoning several members of his family and killing his stepmother. Despite spending his time there studying poisons and experimenting on inmates and staff (one of whom died) prison psychiatrist Dr Edgar Udwin advised the home secretary that Young had been cured and could be released. Following his release in 1971 he poisoned 70 more people – often with cups of tea – two of whom died. Young was sent to Parkhurst Prison where he died of natural causes in 1990. Young does not meet the criteria to be classified as a serial killer.	No	0	3

References

Berry-Dee, C. (2015). *Love of Blood: The True Story of Notorious Serial Killer Joanne Dennehy* John Blake Publishing Ltd. ISBN-13: 978-1784182625

http://www.fbi.gov/stats-services/publications/serial-murder accessed 3/5/15.

Hickey, E. (2009). *Serial Murderers and Their Victims* Wadsworth Publishing Co Inc. ISBN-13: 978-0495600817.

Platt, G. (2015). *The London Underground Serial Killer.* Pen & Sword Books Ltd. ISBN-13: 978-1473827325.

Epilogue

Public to Get a Platform to Discuss the Tubes

A public forum is being launched for tube travellers to comment on new anti-crime measures.

Commuters will also be shown part of the £500,000 security system installed last year at six Northern Line stations in South London.

The first forum takes place on March 30 at Clapham South Station. The discussion could become a monthly event.

It is the brainchild of Transport Police Inspector John Warner, based at Stockwell tube station and Aidan Harris, business manager of the Northern Line in South London.

The police want to make travellers more aware of safety equipment at stations and so ease fears.

They are also keen to foster a better relationship with the public.

Inspector Warner said he was particularly looking for passengers' reactions to platform cameras, panic buttons and glass monitoring booths as stations between Tooting Broadway and Clapham North.

The measures were part of the Government's £15 million improvement package for the Underground.

Inspector Warner said, "We want to ensure the public is aware of what is being done at stations, to allay their fears of crime and to get a more friendly relationship with them so they will report crime to us."

Mr Harris wants to use the forum to discover the public's views on his plans to make tube stations more a part of the community.

Some Northern Line stations already have information boards publicising local events. Mr Harris is keen to extend them to other stations.

He said he would also be looking at better provision

of phones and consultation to have more buses and taxis outside stations to ensure travellers get home safely.

Crime on the Northern Line southern section has halved in the last two years. There have been just a handful of incidents at stations using the new equipment.

South London Press Friday, 3 March 1989

As part of my research for this book, I studied many of the old editions of the *South London Press,* the local newspaper covering Tooting, Balham, Clapham, Stockwell and Kennington. These have now moved from the publisher's former offices at Leigham Court Road, between Brixton and Streatham, where I had studied them in the days after Kelly's arrest in August 1983. They are now held at the Lambeth Archives at the Minet Library, 52, Knatchbull Road, Brixton, in the same road as The Sacred Heart of Jesus Roman Catholic Church, which is where Kelly married his second wife, Frances Esther Haggans. It was while reading about the murder of Kelly's son, Dennis, that my eyes strayed to the adjacent column where I saw the above article and it really got me thinking.

My first thought was that these anti-crime measures might well have been prompted by Kelly's murders. Kelly had been arrested at Clapham on 4 August 1983 and had appeared at the Old Bailey the following year, in 1984. The article in the *South London Press* was published in 1989 and stated that the work had been completed the previous year, in 1988. Four years sounds about right for allocating budget, planning, scheduling, implementing and completing the installation of CCTV cameras, panic buttons and glass monitoring booths on the platforms.

Kelly had admitted crimes at nine Northern Line stations in south London:-
1. Tooting Broadway
2. Tooting Bec
3. Balham
4. Clapham South
5. Clapham Common

6. Clapham North
7. Stockwell
8. Oval
9. Kennington

The London Underground/British Transport Police initiative covered the first six stations on the list although all nine stations have now been suitably equipped. The six stations included the three Clapham stations, which all included the 'single island platforms' with railway lines on both sides of the narrow platforms that had not hindered Kelly in his crimes.

Although it wasn't part of the anti-crime initiative, the installation of electronic ticket barriers throughout the London Underground network was happening at about the same time. It dramatically reduced the number of people hanging around underground stations just to keep warm. This would also have had a positive effect on reducing crime.

My second thought was: 'I wonder how many lives this initiative will save?' Upon reflection, it was clear that it would, in itself, not save a single life, as calling for assistance does not achieve anything unless there is staff available to respond to the incident. Rapid response teams in fast cars cannot get to the platform in time to prevent assaults but CCTV cameras can be used to ensure that offenders are caught before they re-offend.

My next question was: 'Why was this anti-crime work not done earlier?' While cost was undoubtedly a major factor, it is also likely that there was a failure to recognize the risks that existed with somebody like Kelly at large.

In practice, only the electronic doors installed when the newest line, the Jubilee Line was built can provide complete safety for passengers. However, these cost money and may take many more years to install throughout the tube network. An enquiry into London Underground revealed that there are no plans for these doors to be installed universally.